WILDLIFE PAINTING
TECHNIQUES OF MODERN MASTERS

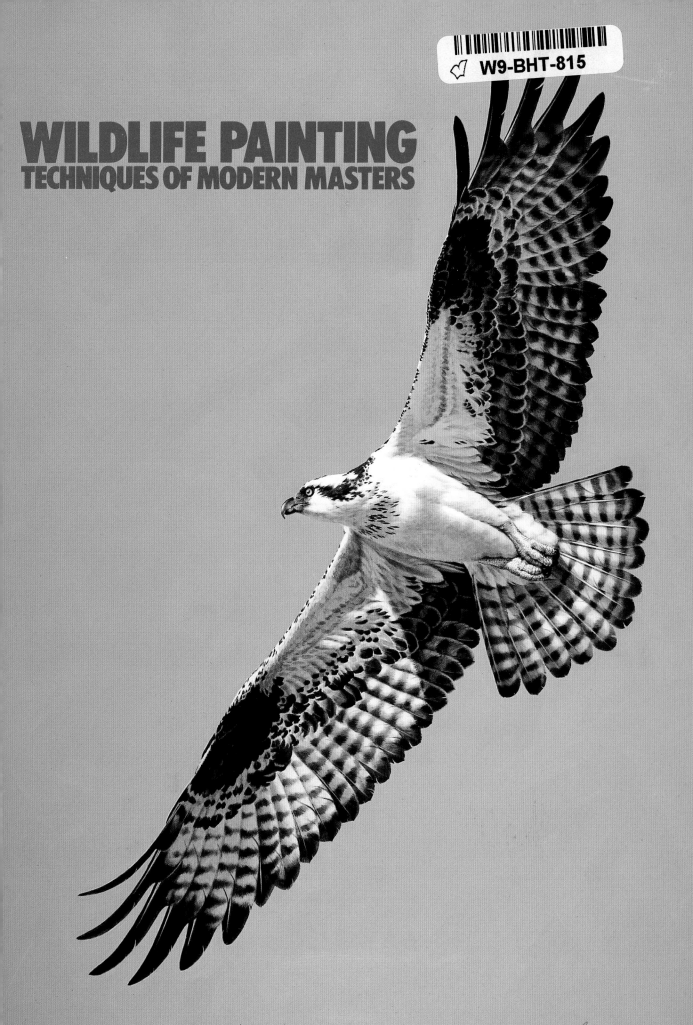

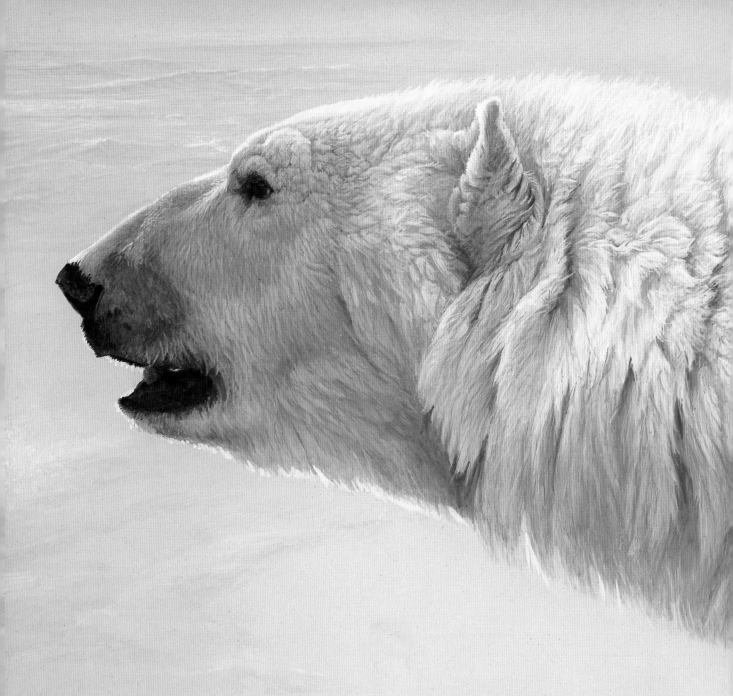

WILDLIFE PAINTING
TECHNIQUES OF MODERN MASTERS

BY SUSAN RAYFIELD

WATSON-GUPTILL PUBLICATIONS
NEW YORK

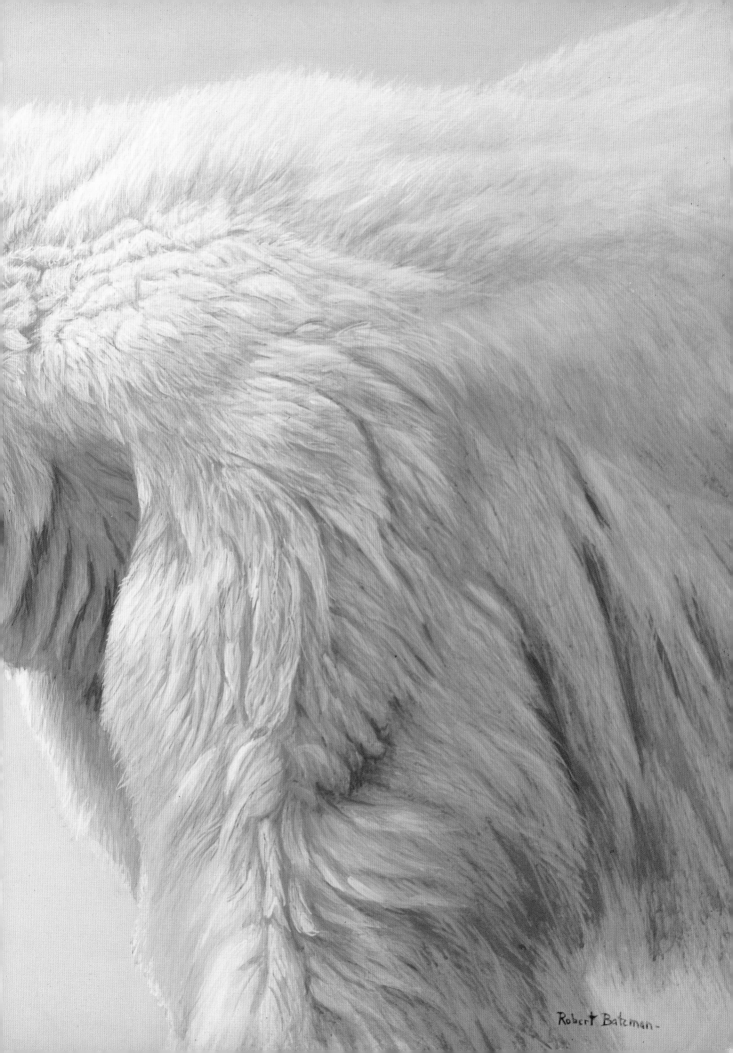

Robert Bateman

*For Carile, Anne and Dave
and the farm, whose woods, brooks,
and rolling hills taught me
about the natural world.*

Paperback Edition
First Printing 1990

Copyright © 1985 by Watson-Guptill Publications

First published in 1985 in New York by Watson-Guptill Publications,
a division of BPI Communications, Inc.,
1515 Broadway, New York, N.Y. 10036

Library of Congress Cataloging-in-Publication Data
Rayfield, Susan.
 Wildlife painting techniques of modern masters.
 Includes index.
 1. Painting—Technique. 2. Animals in art. 3. Birds
in art. I. Title.
ND1380.R36 1985 751.4 85-711
ISBN 0-8230-5750-X
ISBN 0-8230-5748-8 (pbk)

Distributed in the United Kingdom by Phaidon Press Ltd.,
Musterlin House, Jordan Hill Road, Oxford

Manufactured in Japan

1 2 3 4 5 / 93 92 91 90

page 1.
Osprey by Guy Coheleach. 1983, gouache
and acrylic, 30″ × 40″ (76.2 × 101.6 cm).

pages 2–3.
Polar Bear Profile by Robert Bateman.
1976, 24″ × 36″ (60.9 × 91.4 cm).

ACKNOWLEDGMENTS

Above all, I am grateful to the artists in this book, who so generously shared their time, knowledge, and friendship with me, over the course of many months.

It was a great pleasure to work with Bob Lewin, Dick Lewin, Mary Nygaard, and the staff at Mill Pond Press, Venice, Florida. I am also thankful for the efforts of Russell Fink, Lorton, Virginia; Martin Wood, Collectors Covey, Dallas, Texas; and Leslie Ware, *Audubon* magazine, for her excellent help with the biographies. In addition, I wish to thank Guenther Brandes, Gabriele Reddin, Sandra Crabtree and Davis Finch.

At Watson-Guptill, my thanks go to Mary Suffudy and David Lewis, for their encouragement and counsel; Candace Raney, for her sensitive and intelligent editing, and Jay Anning, for the strong design.

CONTENTS

CREDITS

INTRODUCTION

"Wildlife art is an illusion," I heard time and again, as I talked with the eleven master artists whose work is reproduced on these pages. It is precisely *how* they have managed to translate the three-dimensional world of nature to a flat surface, with just a few lines and some color pigment, that is the primary focus of this book.

The degree to which the illusion succeeds depends, in large part, on the artist's technical competence and powers of observation. Painting wildlife imposes the discipline of accuracy. New Zealand artist Raymond Ching points out that, unlike a bowl of fruit, where the objects may vary in size and color depending on the artist's interpretation, a particular species of bird or animal will always have the same proportions and markings, wherever it is seen. "If one is going to draw a blackbird, one has to get it right—there is little room for invention."

Skill and precision, then, are important aspects of this work, but blind imitation of nature does not produce art. "Any true wildlife artist is in the grip of something beyond himself," says Bob Kuhn, who has studied, drawn, and painted animals with a passionate intensity since the age of five. It is the highly personal way in which each artist selects, enhances, or eliminates elements in a painting that lifts the work up and takes it beyond "realism."

The aids that wildlife artists use to achieve their results are many and varied, including specimens, study skins, and photographs, but the essential ingredient, common to them all, remains an intimate, first-hand knowledge, which can only be accomplished by spending many hours observing the living subject in the field.

The artists selected for this book work in a wide variety of media, with styles ranging from meticulous realism to bold impressionism. Some start with a carefully detailed drawing, others prefer to capture the essence of a subject with a quick gesture sketch, or in rough strokes applied directly to the final surface. Painting methods also vary, depending on the artist and the situation. Many begin with the main subject, others from the whole scene; some work dark into light, or prefer the opposite, regardless of the medium; a few paint all over at once, others start in one area and work methodically down the surface until they are through. There is no *one* way to paint wildlife.

Even these accomplished professionals did not achieve their present status without a struggle. "Painting and drawing bravely and well is difficult, hard work," says Thomas Quinn. "It is pure magic if paint looks as if it willingly leaped from the brush." He starts each day with some hand-eye drills, beginning with a series of controlled ellipses with a soft pencil and finishing with a page or two of intersecting lines and configurations, in unforgiving pen and ink. Quinn tries to quit each day while there is still something obvious left to be done, allowing his subconscious mind an opportunity to review the progress, direction, and problems, and provide him with a fresh supply of graphic solutions.

When a painting goes flat on Robert Bateman, who often experiences a period of discouragement after the start of a new picture, the artist puts the work in a frame, which helps him see where he can develop the forces in it. Allowing a painting a fallow period, away from the easel, often clarifies flaws in reasoning and execution, making it easier to move ahead again. At some point, however, every artist must acknowledge major mistakes, or fall prey to the temptation to chase a bad idea too far. Then it is important to know when to jettison a work-in-progress and begin again.

Learning from the material presented here is one way to acquire some of the skills needed to become a wildlife artist. Another is to study paintings in museums, from Rembrandt and Degas to the abstract expressionists. In the end, however, each artist must find his own answers, develop her own means of expression, and then strive to convey that personal experience to others. "What I want to do is paint a picture that will make you feel the way I felt," says Raymond Ching. In that simple goal lies the essence of wildlife art.

—*Susan Rayfield*

BIRDS OF PREY

Robert Bateman

Raymond Ching

Guy Coheleach

Lars Jonsson

John Seerey-Lester

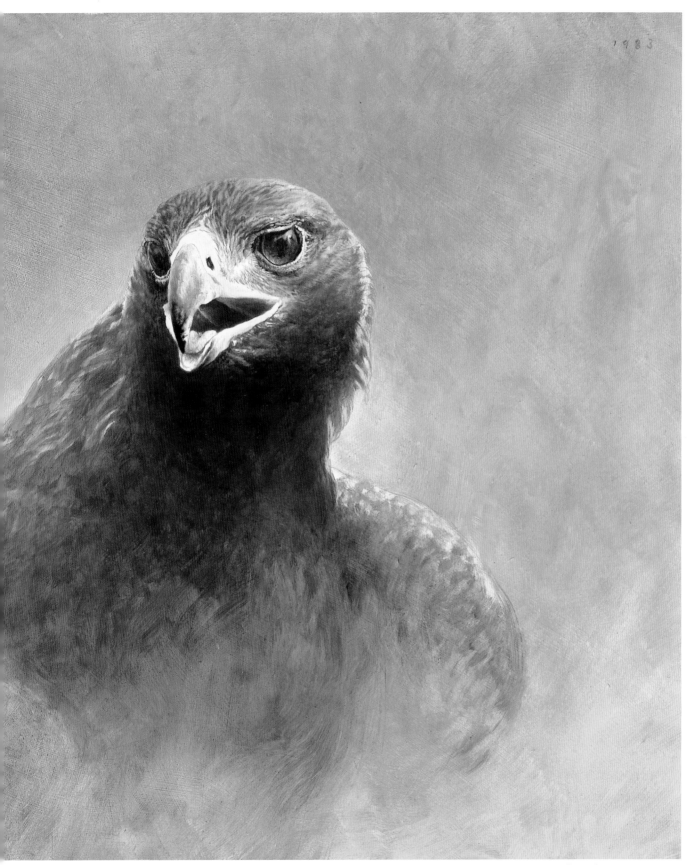

Raymond Ching, *Golden Eagle*, 1983, oil, 14″ × 18″ (35.5 × 45.7 cm).

RENDERING FEATHER TRACTS
Guy Coheleach

VANISHING MAJESTY

1984, gouache and acrylic, 30" × 40" (76.2 × 101.6 cm).

When Guy Coheleach was commissioned to paint one of the subjects for which he is best known—birds of prey—he chose a style that has won him much acclaim—meticulous realism. The result, *Vanishing Majesty*, took months of preparation and involved the careful reworking of many sketches and semifinal drawings, as well as the use of reference photographs and study skins.

In this portrait, Coheleach reveals his knowledge of a bird's basic structure. Its plumage consists of groups of feathers, called feather tracts, which vary in size and shape according to the type of bird. Every bird has a specific number of feathers within each tract, which is as distinctive a feature as the number of fingers on a person's hand. Although it is not always necessary to delineate every feather, when that is the intention, the count must be correct.

The final, tightly rendered drawing of the eagle was mechanically enlarged and transferred to the illustration board. The bird's extended wings clearly show the arrangement of its long, grayish-blue flight feathers—the ten primaries, which Coheleach has spread like the slats in a Venetian blind, and the row of twelve secondaries just below them. Starting at the top of the wing, and protecting the rest of the surface with tracing paper, the artist painted the primaries with a thin wash of phthalo blue and burnt umber gouache, using a number 7 sable brush. Next, Coheleach painted the brown portion of the wings, the underwing coverts, with a combination of raw sienna and burnt sienna. He completed the lower wing in a similar fashion, adding a pale wash to indicate the reflection of light. In cases where both wings are of equal size and shape, Coheleach often will reverse the image of the first in a mirror to complete the second one.

The eagle's body plumage was carefully delineated, followed by its twelve tail feathers. The claws and beak were painted in yellow ochre, with cadmium primrose highlights. To achieve a chalky look on the head and tail, the artist mixed white with some raw sienna, phthalo blue, and burnt umber. As a final touch, he added a grayed sheen to the bird's upper breast and along its legs, where the plumage catches the light.

The most important part of the bird, the eagle's head, was saved for last. Viewed from the side, its eye is elliptical, not round, and the clear lens reflects the sun as a golden highlight. Like all birds of prey, the eagle has an overhanging brow that casts a shadow across the top of its eye.

Coheleach prefers to use acrylic for backgrounds because it covers well. Here, the artist wanted a simple setting to offset the detail in the bird. He flowed a fairly liquid pigment onto the board with a one-inch flat bristle brush, then smudged it somewhat to get a softer look. When he finished meeting the sky with the bird, the artist went over the edges of the eagle with some of the acrylic to blend it with the background so that it wouldn't pop up like a cutout.

Coheleach laid in the darkest part of the flight feathers with a heavy black stroke, then mottled them with a mixture of phthalo blue and burnt umber.

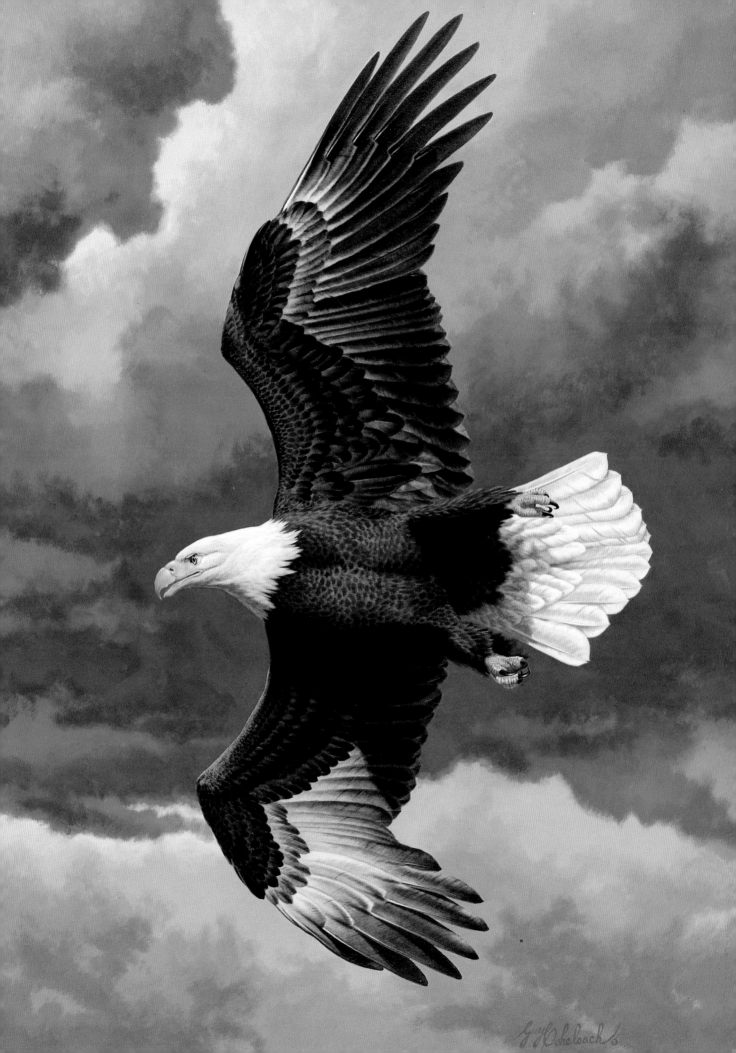

CAPTURING THE FORM AND PATTERN OF WINGS
John Seerey-Lester

PLAINS HUNTER—PRAIRIE FALCON

1983, oil, 17½" × 23⅞" (44.4 × 60.6 cm).

Unlike most birds of prey, the prairie falcon is usually seen close to, or actually perched on the ground, seeking out rodents, reptiles, and even large insects. By portraying the bird at eye level, the artist further enhances the sense of vast, open space. The lines of the cloud formation, which slant from right to left, and the slope of the rock, from left to right, converge on the falcon as the focus of the painting. The intricately detailed terrain does not detract from the bird, which stands in sharp contrast against a large area of sky.

As with all of his paintings, John Seerey-Lester started with the main subject. Working from photographs and sketches, he drew the falcon on the canvas with a charcoal pencil, then filled in the head area with a mixture of raw sienna, burnt sienna, Naples yellow, and a bit of burnt umber. For the success of the painting, it was important to show the shape and arrangement of the decorative wing and back feathers accurately. To achieve this, Seerey-Lester first painted the lighter outline around each feather in white. After the pigment had dried, he then covered the entire back of the bird with a thin brown wash, which dried darker directly on the canvas and paler over the white areas, so that the edges of the feathers stood out. The artist then added detail in the darker portions and picked out the edges again, using a pale mix of yellow ochre and white, and a touch of raw sienna.

Initially, the falcon's white plumage was painted darker with a mixture of Payne's gray and white. Lighter areas were overpainted in a cool, off-white. Seerey-Lester then added the details in progressively paler colors, layer upon layer, to give the illusion of depth. The darker areas of the falcon are painted with a combination of burnt umber and ultramarine blue. Its feet and the base of its beak are yellow ochre and zinc yellow, with a bit of flesh pink. The shaded parts are basically burnt umber mixed with Naples yellow.

Upon finishing the bird, the sky was painted with a house brush, using an equal mixture of cobalt blue and ultramarine. Seerey-Lester worked from the top down, adding more white as he neared the horizon. Using a fine, long-haired brush, he painted the upper clouds in white, with a touch of Naples yellow and flesh pink. To get the soft feathery look, he blended them into the sky with a dry brush, then used his fingers to blend the thicker, lower clouds.

The rock ledge on which the falcon is perched was painted in burnt umber and ultramarine blue. Its sunlit surfaces are mainly burnt umber with a lot of white. Here and there, Seerey-Lester introduced some yellow ochre mixed with cobalt blue for a greenish cast, which gives the rock a weathered look. The richly detailed landscape is a composite of many sketches, photographs, and actual plant samples. Seerey-Lester added some trails in the distant hills to demonstrate man's presence in this bird's territory.

Seerey-Lester began with the bird itself, then proceeded to rough in the sky and landscape. At that point, he hadn't decided whether the falcon woud be on a rock or a branch, and so he left it suspended. He then finished the background, modeled the bird in detail, and completed the rock and the foreground.

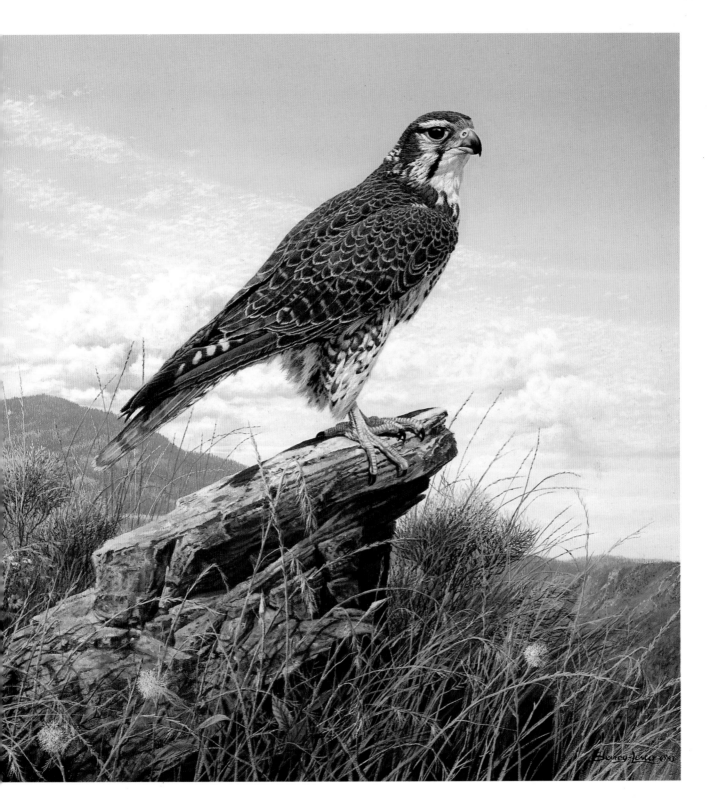

CONVEYING THRUST AND SPEED
Robert Bateman

PEREGRINE FALCON AND WHITE-THROATED SWIFTS

1976, acrylic, 40" × 60" (101.6 × 152.4 cm).

Plunging steeply in a power dive, a peregrine falcon chases two white-throated swifts. The birds are well matched—the falcon's rocketing speed, in excess of 170 miles an hour, will probably not be enough to counteract the rapid aerial maneuvers of its prey. In choosing the cliffs of the Rockies for his backdrop, the artist was aware that the piebald pattern of exposed rock and snowfields echoed the charcoal-and-white plumage of both birds.

To emphasize the peregrine's drop through space, the artist selected a vertical format, underscoring the sense of downward motion by gradually decreasing the amount of landscape detail. He explains, "It's a dangling composition, like a lace curtain that is solidly attached across the top and becomes loose below. The upper part is very precise, crisp, and geometric, almost like building blocks. Then the snow seems to slide down the painting faster and faster, finally opening up into vapor."

Bateman added to the peregrine's thrust by enlisting the frame itself, which is the most powerful line in a painting. He left a fraction of an inch between the frame and the tip of its wing, which acts as a spark gap so that the eye travels down the frame's edge and jumps across, visually propelling the bird forward. The artist also distorted the line of the wing, straightening it and highlighting it in white, to make it act like an arrow leading to the falcon's eye, its beak, and then ahead to its prey.

The swifts, chittering in fear, are shown ricocheting out of a quick dive, giving the composition a hook shape, like the crack of a whip. The motion of the birds is reinforced in the landscape by the vertical snow chutes and the misty suggestion of a treeline in the foothills below, which holds the bottom of the painting and turns the eye back up again. The entire work was accomplished with just four colors—ultramarine blue, burnt umber, yellow ochre, and white, with a fraction of cadmium yellow added to the base of the falcon's beak for emphasis.

Bateman made a sketch of the falcon on bristol board, which he cut out and taped to the painting in various positions to determine its proper placement. The swifts were painted from sketches and a specimen.

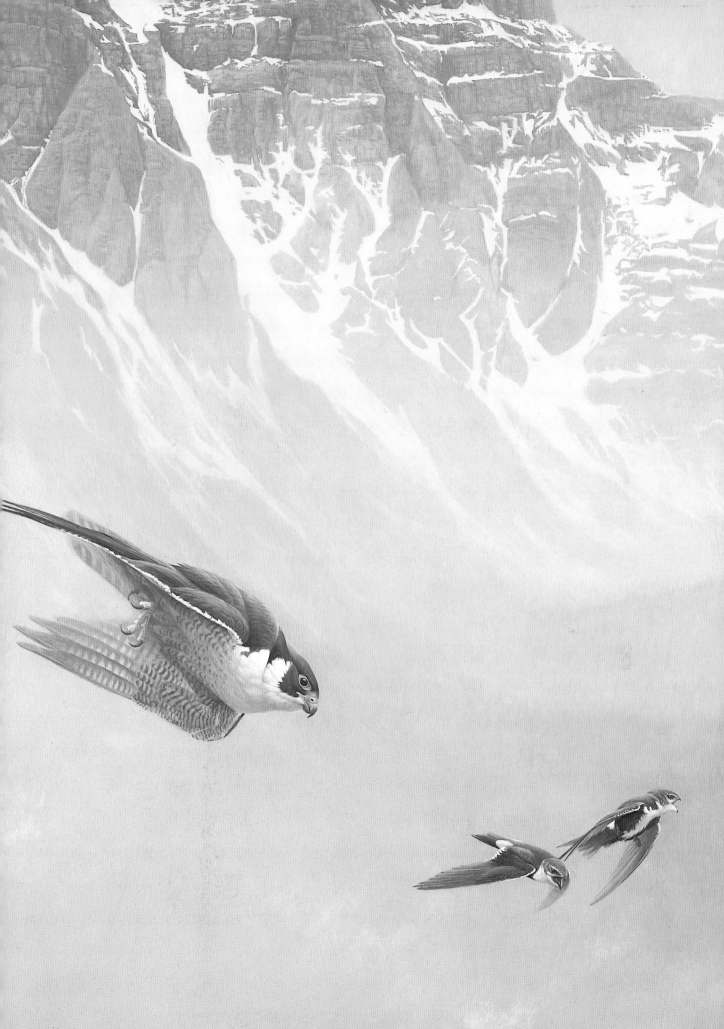

USING A LOOSE, IMPRESSIONISTIC STYLE TO SUGGEST MOTION
Guy Coheleach

HAREE MOMENT

1980, oil, 36" × 72" (91.4 × 182.8 cm).

The encounter between predator and prey, life and death, is a predominant theme in Guy Coheleach's work. Here, a golden eagle closes in on a white-tailed jack rabbit, its powerful talons swinging forward as it brakes for the kill. Will the rabbit bound to safety? The uncertainty of the outcome is the pun behind the title of *Haree Moment*, a loose, impressionistic oil inspired by the work of the early twentieth-century master Bruno Liljefors.

For Coheleach, much of the real work on a painting is done in the pencil stage. He starts with a rough drawing to establish the composition, then selects a dozen thumbnail sketches of the subjects from among hundreds that he has made over the years. In this case, Coheleach worked up several eagle sketches on tracing paper, changing the body positions and refining anatomical details. He shaded a few to make sure that the modeling was correct, using a file photograph which showed the underside of an eagle with the lighting he wanted. After finishing off the sketch he liked best, the artist enlarged it and transferred it directly to the canvas in black acrylic paint, using the same proportions that had been worked out in the compositional rough. At this point, the final design was set and few further changes were made. A similar procedure was followed for the rabbit.

Coheleach began to apply color by establishing the eagle's darkest and lightest values, a technique he employs to avoid having to adjust his range later on. Using a large, square bristle brush, the artist worked rapidly, laying in the strong blacks of the wings, chest, and tail with phthalo blue and burnt umber. After establishing the darks, Coheleach applied yellow ochre to the beak and feet. Next, he painted the gray tones in the wings, with a mixture of violet, raw umber, and yellow ochre. Finally, highlights on the beak and talons were added with cadmium yellow light, straight out of the tube.

The rabbit was roughed in quickly in yellow ochre, with burnt umber and ultramarine blue used to build the darker areas, and white for the base of the ears, rump, and tail. The broad brushstrokes give an unfinished, spontaneous feeling. The same combination of colors, in different proportions, make up both the shadows and the snow, which are slashed on boldly. Coheleach, who paints in a variety of media, and who is equally capable of handling tight detail, chose to work this oil in a loose, painterly manner to convey a sense of motion and immediacy.

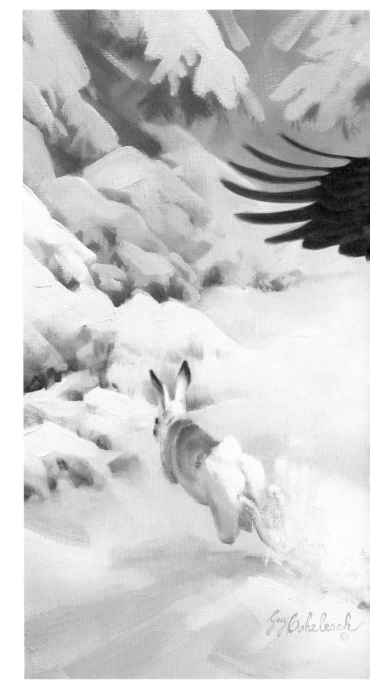

Seen close-up, the eagle's talons become an impressionistic blur, painted in gobs of yellow ochre more than half an inch thick.

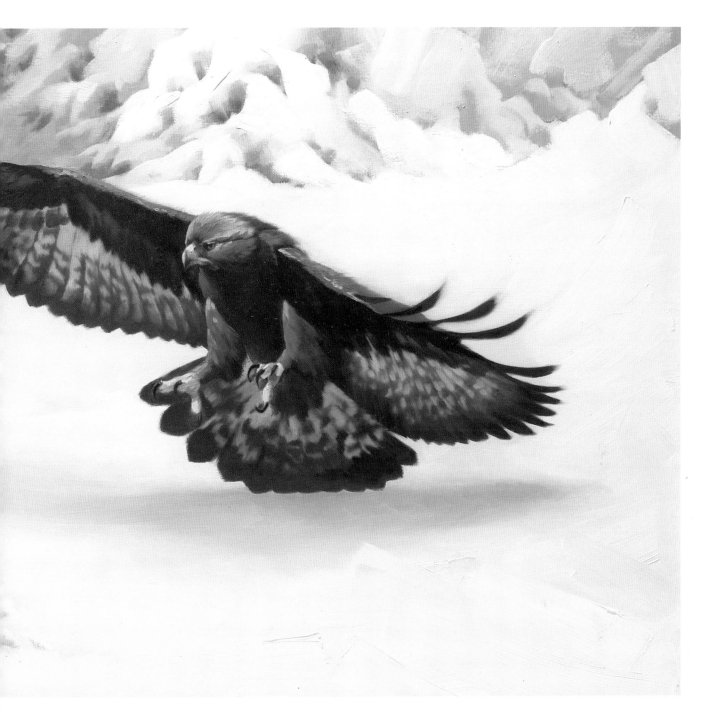

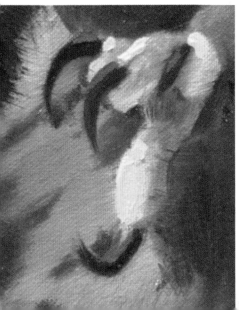

Manipulating Light and Shadow
Robert Bateman

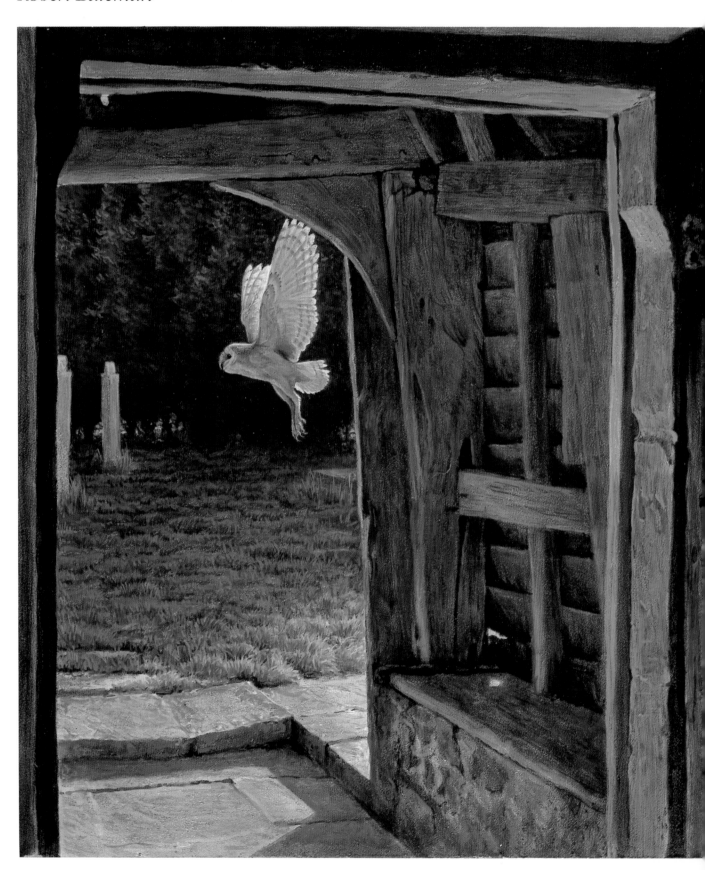

Bateman made several thumbnails to experiment with the placement of the owl in relation to the tombstones and to determine the balance of the light and shadow.

BARN OWL IN THE CHURCHYARD

1979, oil, 16" × 20" (40.6 × 50.8 cm).

Pale, silent, mysterious, a barn owl glides past the doorway of an ancient church in Wiltshire, England. On several occasions Robert Bateman had spent evenings in the vicinity, looking for birds and enjoying the textures of the old timbers and stones that had been laid down many centuries before.

Although he did not see this exact view, the artist wanted to paint a picture that captured the feeling of being in the church in the early morning. To construct a scene that he had never actually witnessed, at an unfamiliar time of day, he had to manipulate the light, imagining where the shadows would fall at that hour. The artist was particularly concerned with getting enough light to bounce into the building without losing the contrast between its dark interior and the bright courtyard beyond.

Bateman began the composition with the placement of the doorway, then played with the position of the owl, and finally the tombstones in relation to the bird. To insure a balance throughout the picture, he painted all over at once, working with one color on different sections, until it was used up before going on to the next.

The barn owl was painted a fairly transparent white, which was then toned down with shadows. "I use my real lights and real darks as aces," Bateman explains. "The native color is not as important to me as showing the form and having my lighting consistent." The owl is flying over bright grass, which acts like a bounce light, reflecting green onto the underside of the bird. Bateman has noticed that shaded areas on a white bird often take on a greenish cast caused by the overlapping of blue shadows and the yellow light-struck areas. To the artist, green also conveys a sense of spirituality, which was an important component of this painting. He explains, "Throughout my life, the few times that I have seen a barn owl have had an unexpected quality. In each case I have been prowling quietly in or near old buildings. Feeling a bit like an intruder, I have been startled by its silent flapping. Perhaps because of my mood or perhaps because of the surprising paleness of the bird and the fleeting glimpse, the thought of a ghost would spring to mind."

In addition to his usual palette of burnt umber, ultramarine blue, yellow ochre, and white, Bateman added little bits of Prussian blue here and there—in the old metalwork on the door and in the grass—to give it freshness.

Capturing Subtle Color Patterns
Lars Jonsson

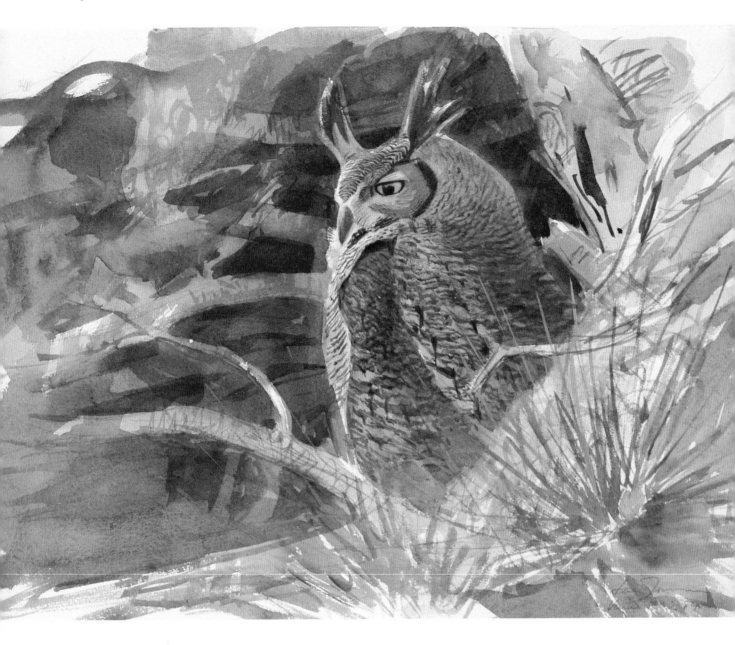

Jonsson felt that making sketches of the nest and the young was necessary to fully understand the owls. He often sketches through a telescope to enable him to get close enough for an intimate feeling of the subject, and to help simplify the surroundings.

GREAT HORNED OWL

1984, watercolor, 19" × 14½" (48 × 36 cm).

One of the first subjects that Swedish artist Lars Jonsson observed and worked with on a spring visit to America was this great horned owl's nest, actually the abandoned nest of a bald eagle, set high up in a pine grove in southern Florida. Initially, the artist's attention was drawn to the young birds, and he made several sketches of them before noticing that the adult female was sitting quietly among the branches just below. "I immediately thought—this is something I want to paint!" says the artist. "When I do field work I'm never sure what will come of it. I don't plan a picture for a gallery. I do it because it's my life to do it—because I love it. But when I see something that really excites me as a subject for a painting, I go out and make studies for it." Jonsson did a series of pencil sketches and painted a watercolor that very evening, then returned and finished a second study a few days later.

The artist focused on the owl's eyes and expression, letting its contours blend with the surroundings, just as he had seen it. All owls have soft plumage, well suited for their silent flight. Often, individual feathers are not apparent; instead, what is seen is an overall pattern of subtle colors—brown, ochre, gray, and white. To convey this feeling, the artist avoided hard edges and kept the feathers loosely painted.

When Jonsson begins a watercolor, he first lays in a background tone to have something to paint against. Here, he mixed burnt umber, ultramarine blue, and ivory black, using a watered-down version for the owl's back, wings, and the shadow areas on the tree. As he worked, the artist was careful to leave a crisp white line where some parts of the owl—its breast and ear tufts—caught the light. The rest of the bird was roughly blended into the background. Jonsson usually allows colors in the surroundings to merge with parts of the bird to avoid sharp contours, which would make the subject pop from the background like a cut-out.

The artist simplified the owl's plumage, making no attempt to render every line of its intricate pattern but putting in just enough to convey the sense of detail. In some areas, he worked wet-into-wet to soften the look, such as the suffused green areas on the wing. In others, like the back of its head, Jonsson took up some of the color by going over it with a brush and water, then blotting it with tissue. This technique, which he uses quite often, also provides a feeling of air and gives a slight shining effect.

For the pine needles, Jonsson used Hooker's green grayed with yellow ochre. Here again, he chose not to delineate every needle but, where he wanted some crisp lines against the bird, he mixed the green with white gouache. The barring on the breast and details of the owl's face were put in last. The rusty area on its cheek is a combination of Winsor red, some burnt umber, and yellow ochre. The owl's prominent brow shades the inner portion of its eye, which the artist has painted a duller gold. Eventually this watercolor became the basis for a large oil.

POSITIVE AND NEGATIVE SPACE
Robert Bateman

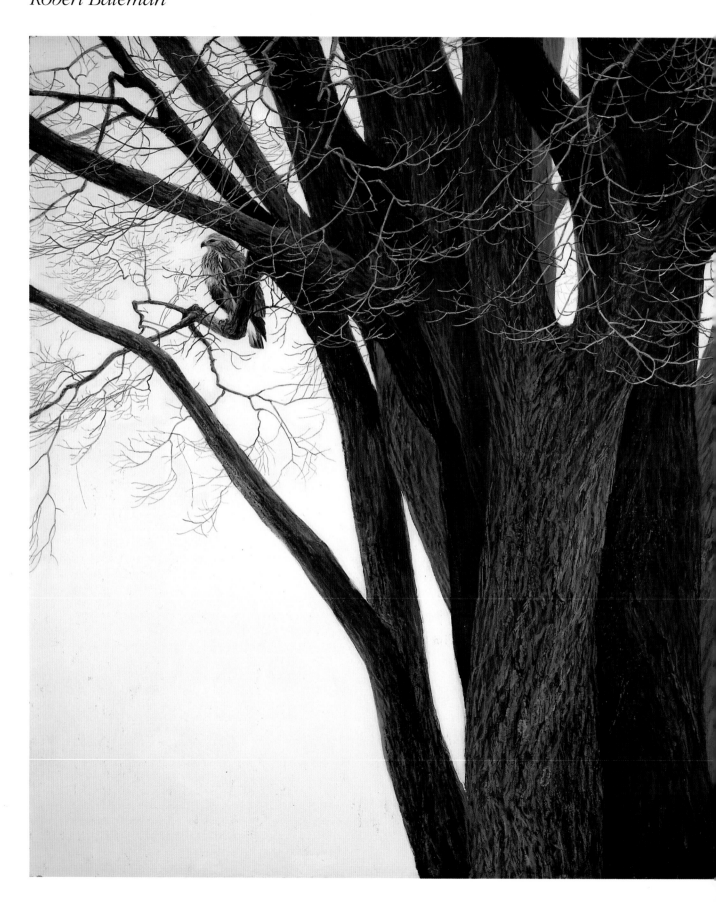

ROUGH-LEGGED HAWK IN ELM

1966, acrylic, 36" × 48" (91.4 × 121.9 cm).

Rough-legged Hawk in Elm is a pivotal work for Robert Bateman, marking his transition from abstract expressionism to realism. The painting was begun in 1962 as a black-and-white, purely abstract design of the tree, at a time when the artist was strongly influenced by the work of Franz Kline and by oriental calligraphy.

From a window on the second floor of a farmhouse, Bateman found a vantage point from which he could look directly into the middle of a magnificent old elm. Struck by the powerful positive and negative spaces that were created by its dark trunks and branches, he made a bold, slashing portrait with just a few brushstrokes.

Three years passed, during which time the artist saw his first exhibition of paintings by Andrew Wyeth, an event that was to radically change his direction. Bateman explains, "Here was an artist involved with the real world, who wasn't concerned with only the surface of the paint, as I was then. When I saw the Wyeth show it all came together, and I realized I was interested in the distinctions between trees as well as the mass of form and color. I went back to naturalism, but kept the impressionism and cubism as underlying concepts for picture ideas."

Bateman decided to rework the elm abstract, adding texture to the bark and building the tree by working on the big forms first, gradually getting more and more refined. He began by scraping down the original black blobs of oil paint with a razor blade, then drew in the large, braided ridges of bark with Payne's gray, mixed with white and some yellow ochre. These areas were broken up with small, dark, hook-shaped shadows, done in Payne's gray and burnt umber, and with fine highlights.

Bateman then spattered the whole surface with darks, which became the bark crevices, and some lights. He added dark little flakes with a small brush, and then put in some orange, green, and yellow-green accents to indicate clumps of lichen clinging to the bark. Finally, he added a very thin dark wash overall to sculpt the surface and to create little paths connecting the original braided areas.

The delicate frieze of branch tips dangling in space far in front of the massive trunk system arc across the picture with a swinging motion. Using a number 2 brush, Bateman drew them carefully, exactly as he saw them, in white and yellow ochre. "I tried to think and feel what each branch was doing," says the artist, "and I kept in mind that the tips were pointed directly at the viewer, not in profile." To model the forms, he added shadows in burnt umber, with some yellow ochre and Payne's gray. The color of the twigs is redder and warmer than the tree, which brings them forward. It becomes an abstract element, forming a lacy band across the top of the painting.

HUNTERS AND THE HUNTED: LARGE ANIMALS

Robert Bateman

Ken Carlson

Bob Kuhn

John Seerey-Lester

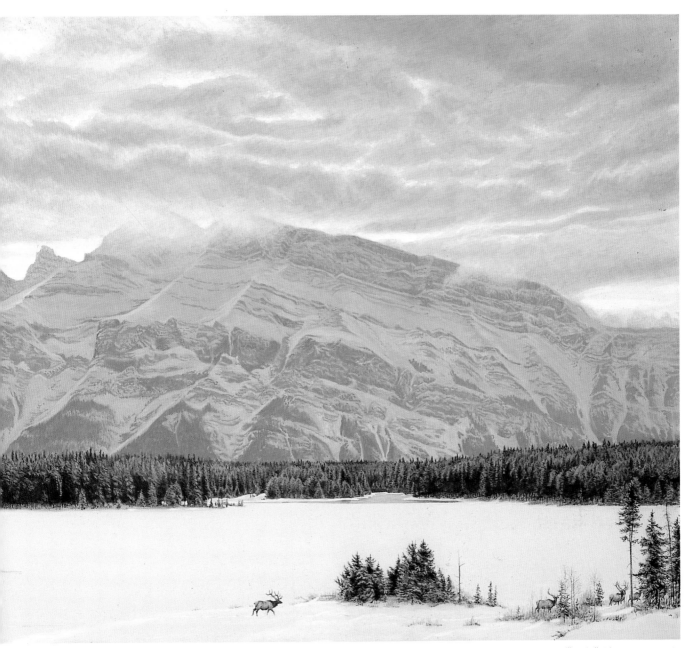

Robert Bateman, *Awesome Land—American Elk,* 1980, 24″ × 43″ (60.9 × 119 cm).

Using a Bold Drybrush Technique to Indicate Fur
John Seerey-Lester

As seen in this close-up, portions of the Frederix heavy duck canvas show through the final work, giving the face of the cougar a frosted look. Its extraordinary eyes are the key to the painting.

WINTER LOOKOUT—COUGAR

1983, oil, 23½" × 17⅞" (60 × 45.4 cm).

A magnificent male cougar stares out from his secluded shelter, gaze fixed on something beyond the viewer. For John Seerey-Lester, the eyes of an animal are the most important part of a painting, and he always does them first, knowing that if they are unconvincing, the rest of the work be unsuccessful. Here, he indicated their curvature with a white highlight that picks up the sun, and by a pale wash at the bottom rim, which reflects the surrounding snow. The upper portion of the eye, shielded by the brow, is darker. Cougars' eyes become more blue as they get older, and Seerey-Lester has painted the intense eyes of this mature animal with a mixture of cobalt blue and white.

The body of the cat is underpainted with a dark wash of burnt umber, burnt sienna, and ultramarine blue, which comes through in the final work in the area of the cougar's nose. Using a large, dry brush, Seerey-Lester built up its rich tawny coat by blocking in areas of burnt sienna and raw sienna, using bold strokes to give the illusion of fur without painting many individual hairs. He painted the paler fur on its chest and hindquarters by dusting on a mixture of white, Naples yellow, and a bit of red with a fan brush and then blending it with his fingers for a soft effect.

The play of light and shade on the cougar's shoulders adds interest and helps the cat blend into the background. Seerey-Lester softened the edges to avoid a sharply defined line, which would give the cougar a silhouetted look. Initially, the animal was sitting in grass and the background was much lighter. Seerey-Lester painted in the trees and leaves in reasonable detail at first, then drybrushed burnt umber, ultramarine blue, and purple over the area to deaden it and push it back. The result is a dark, filtered look. The sprays of needles on the right, painted with a number 1 brush in little flicks and sweeping strokes, was done in shades of cobalt blue mixed with yellow and white. They provide an important contrast and add a cool note to the otherwise warm work.

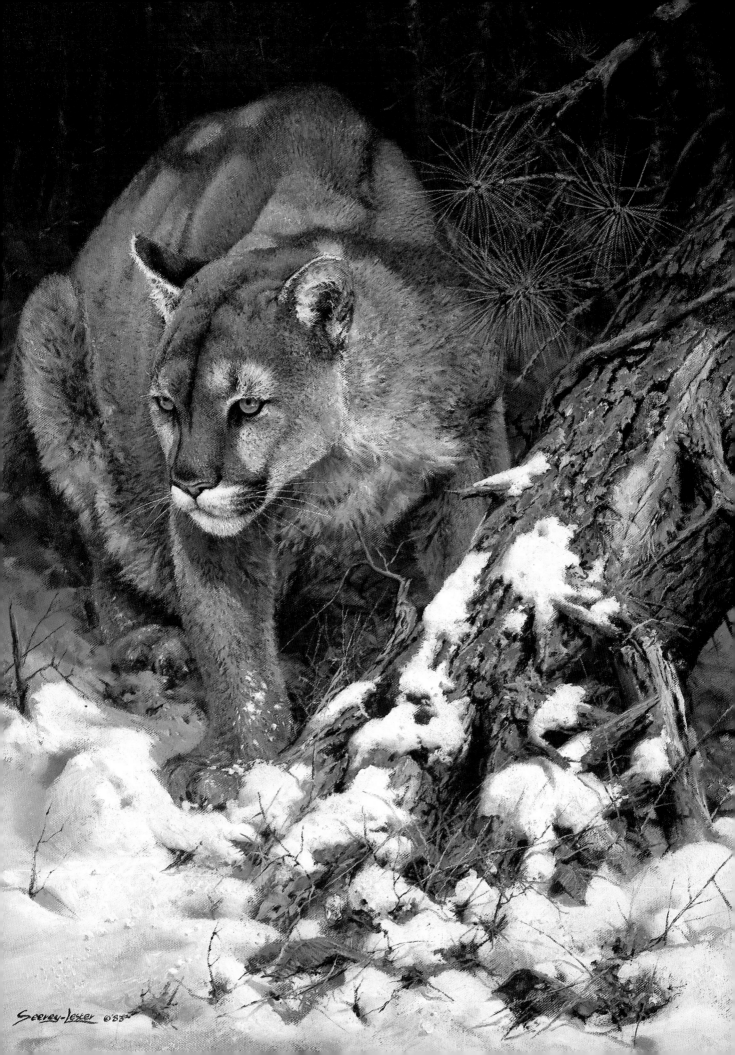

Painting Animal Tracks in Snow
John Seerey-Lester

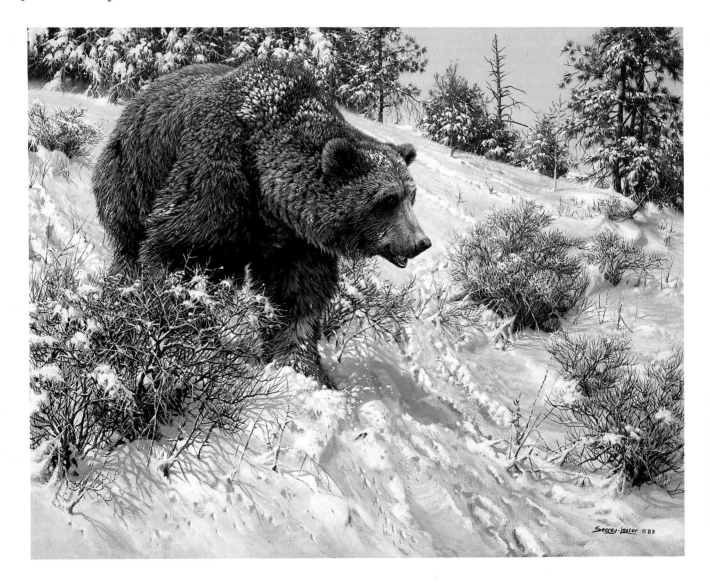

First Snow—Grizzly

1983, oil, 20" × 24" (50.8 × 60.9 cm).

Large animals frequently are shown against a snowy backdrop, which provides a dramatic contrast for their dark coats, and acts as a simple counterpoint to the richly detailed fur. John Seerey-Lester is particularly skillful at showing winter effects. "I always begin painting snow as though it's in cool shadow," explains the artist. "I use a small amount of metallic silver, cobalt blue, with Payne's gray and plenty of flesh pink and white. Then I start building the surface according to the angle of the sun or the light that is being reflected."

First Snow—Grizzly shows soft, freshly fallen powder in bright sun, crossed with many bird and animal tracks. The flying pieces of snow in front of the bear's foot convey its looseness. The artist has overpainted the base shadow color with flesh pink and white mixed with a small amount of metallic silver, which creates a luster and deadens the white.

The grizzly's coat was built up with an initial dark wash of burnt umber and ultramarine blue, to which rich browns—burnt sienna, yellow ochre, and a touch of raw sienna—were added, stroke by stroke. The artist highlighted the bear's fur with bits of clinging snow, adding some shadow in the area as well, to convey depth.

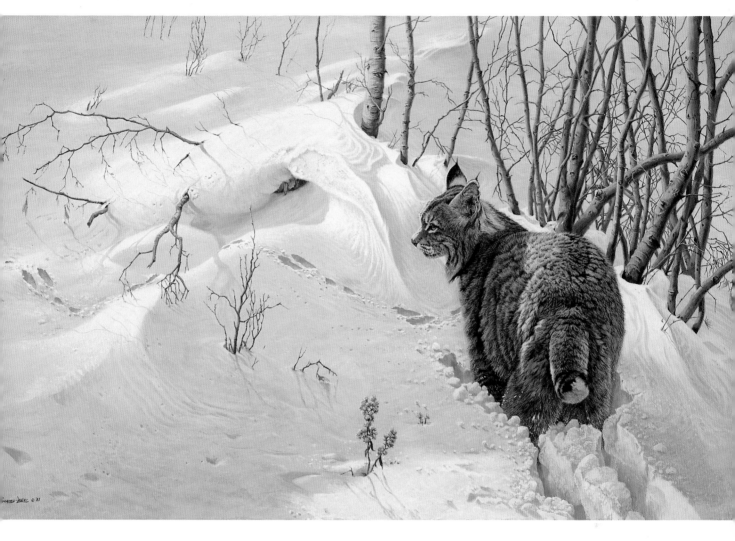

CLOSE ENCOUNTER—BOBCAT

1983, oil, 48" × 30" (121.9 × 76.2 cm).

In *Close Encounter—Bobcat*, the sun is low and much of the snow is in shadow. Here, the hard and crusty deep drifts are undisturbed, except for the tracks of the bobcat and snowshoe hare. Seerey-Lester painted the shadows in this picture with more metallic silver than usual, and added a bit of cobalt blue to the white and flesh pink. The highlighted areas were painted on top of the shadows, and include a touch of strong red and Naples yellow mixed with white, to give it some warmth. The canvas is large—the bobcat is almost life-size—and the brushstrokes throughout are big and bold.

The bobcat's tracks are illuminated here by an inner reflection and appear to be lighter than the surface of the snow. There is more work in the bobcat's deep tracks than in the rest of the painting. Seerey-Lester actually saw the animal in summer, matched it up for the painting with his photographs and field sketches of winter tracks, and also recreated the tracks himself for a visual model. The warm color of the cat is reflected in the walls of snow nearest its body. The spacing of the hare's tracks, also based on photographs and sketches done in the field, accurately reveals its leisurely pace as it left its thicket to forage, unaware of the approaching predator.

CREATING A SENSE OF SPACE WITH FALLING SNOW
Robert Bateman

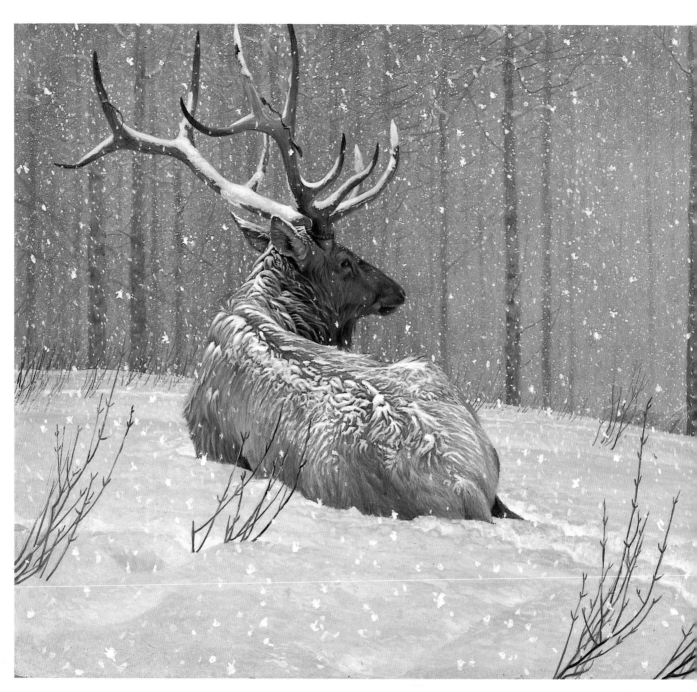

Thumbnail sketches of the major elements determined the composition.

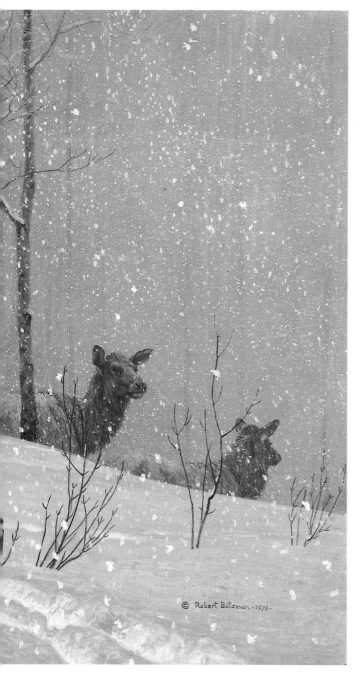

EVENING SNOWFALL—AMERICAN ELK

1979, acrylic, 28" × 48" (71.1 × 121.9 cm)

With night closing in, a bull elk beds down at the edge of an aspen grove, while part of his harem moves farther down the slope. The falling snow and vertical trees lend a tranquil, almost church-like atmosphere to the scene. The snowflakes are not all in one plane but go back and back, in a series of thin veils, creating a feeling of space. "You have to think into the picture," says the artist, Robert Bateman. "There is air between all the elements—the bull elk and the trees behind him, and the two cow elk and the trees in front of them and behind them."

Working over the whole painting at once, the artist spattered some snow flakes and put others in by hand, then painted different areas before returning to the snow again. At first, the effect looked too much like polka dots, which interrupted the rhythms that Bateman was trying to establish. The artist toned down the whole surface with several transparent white washes, which gave the feeling of diaphanous curtains of falling snow, and then patted it with a small sponge to add a varied, lightly textured look.

Bateman had laid in the snow cover at an earlier stage, roughing in dark tracks, which now seemed artificial. To check his perceptions, the artist made an elk-like trail in the snow outside his studio, during a storm when conditions were similar to the scene in the painting. To his surprise, the artist discovered that the inside of the tracks was actually lighter than the top surface. Bateman realized that he would have to paint the snow relatively dark to convey the correct impression, which brought him to the major decision of the painting. "I don't think I've ever used pure white for snow; it's almost every other color," he says. "But I wasn't sure that I wanted it *that* dark in order to make the tracks look white." Eventually, however, he decided to proceed with the dark treatment of the snow cover.

The artist treated the snow building up on the elk's back, in the same way as he would portray snow on a mountain. Little ridges of hair catch more flakes, while vertical breaks in the fur hold less, creating an interesting pattern of fractured lines. The shape of the elk's antlers is echoed by the only conspicuous branch, creating a visual unity. The otherwise vertical trees help to lead the eye into the painting, where horizontal and diagonal lines would have blocked it. Although the mood is serene, and without threat, the ears of all three animals are pointed in different directions, alert for danger even in repose.

Creating the Illusion of Depth in Fur
John Seerey-Lester

High Ground—Wolves

1983, oil, 22" × 29½" (55.9 × 74.9 cm).

Three members of a wolf pack come to a halt on a ridge after running hard in pursuit of prey—perhaps a moose or caribou. Their heavy breathing mists the cold air and their tails hang loose, indicating that they are relaxed and their aggression has subsided. The painting captures the soft quality of early evening light on the tundra, with the low sun behind the animals highlighting their coats and casting long shadows before them. The thin snow in the foreground, with rocks and grass showing through, adds interest and contrasts with the detailed fur.

The coats of the wolves were laid on with a thin wash of burnt umber and ultramarine blue, and built up with progressively lighter shades, stroke by stroke, to give the illusion of depth. Their backs are essentially burnt umber and raw sienna; the tan color on their faces, legs, and tails is a combination of yellow ochre, Naples yellow, and some burnt sienna, mixed with white. The pale areas on the muzzles, legs, and in the fur, which give the wolves a grizzled look, were painted with touches of Naples yellow and flesh pink, mixed with white. Their tongues are burnt sienna, white, and flesh pink, shaded with a bit of ultramarine blue and burnt sienna.

To achieve the effect of misted breath, the artist rubbed some cobalt blue with white onto the canvas, very finely, with a fairly thick, bushy brush. He kept the mixture dry, using colors straight out of the tube, without turpentine, and dusted the surface several times, allowing it to dry thoroughly between applications.

The sky was painted with a house painting brush containing an equal mix of ultramarine, cobalt blue, and some white. The artist worked from the top down, adding more and more white as he proceeded. While the sky was still wet, the artist went over it dabbing with a large, dry brush to remove any evidence of brushstrokes. Then, working from the bottom up, he carried the paint from the light areas into the darker ones, to merge them. Lilac-colored clouds, which the artist blended with his fingers, signal the onset of evening.

The foreground was painted last, to tie in the nuances of coloration and texture between it and the main subjects. Seerey-Lester first roughed in the shaded snow, using a minute amount of metallic silver with Payne's gray, and plenty of flesh pink and white. He then painted the rocks in detail and indicated the grass stems poking through the snow first using the edge of a fan brush and then, adding in the detailed blades of grass with a fine, long-haired brush. The grasses in sunlight were painted with yellow ochre, Naples yellow, and white; the darker clumps are raw sienna, burnt umber, and white. Finally, the artist added the sunlit areas of snow in flesh pink and white, with a touch of yellow, and then went over the whole work again, adding highlights here and there and balancing the color throughout. After studying the piece for a few days, the artist decided that the middle wolf merged too much with the one on the right side, so he strengthened the effect of sun on its fur and brightened up the sunlit areas on its paws and legs to give them a crisper look.

Seerey-Lester began with many thumbnails and compositional studies. Working from field notes, photographs, and sketches, he drew the animals on a tissue, which he moved around the canvas until he found the right position. Transferring the final drawing, seen at right, to the canvas with a charcoal pencil, the artist sprayed it with fixative, which enabled him to apply washes of oil and still see the drawing underneath. He began the painting with the wolves themselves, starting at their heads and moving toward their tails, working

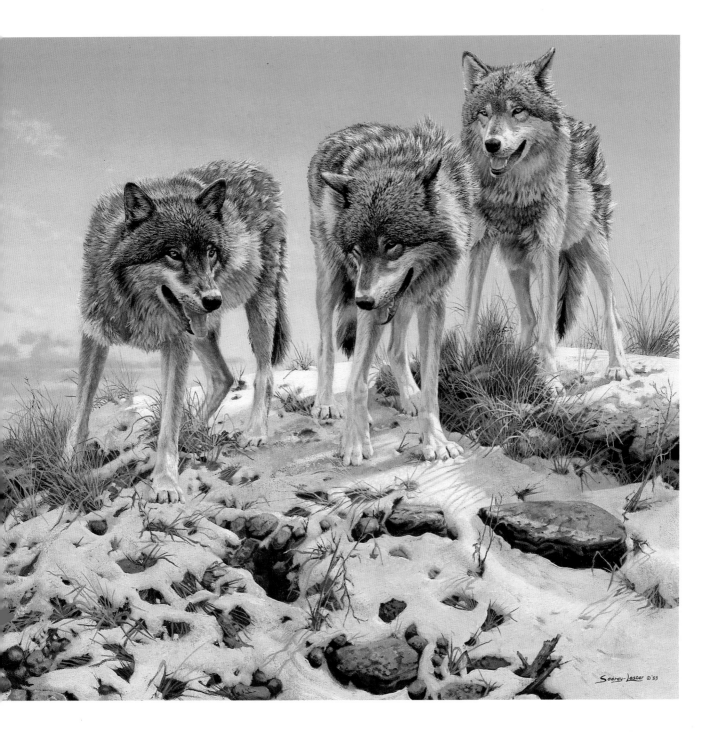

dark to light. The artist concentrated on one area at a time, building it up with small amounts of all the colors he planned to use.

The background, which was painted directly onto the canvas without a preliminary drawing, changed several times during the course of the work. At one point it was a woodland scene but the artist felt that it detracted from the wolves and so he simplified it, keeping just the sky and a few trees on the horizon. At far right, you can see an early, simplified version of the background.

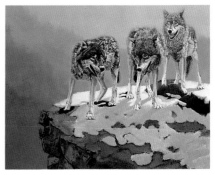

BUILDING FORM WITH REFLECTED COLOR
Ken Carlson

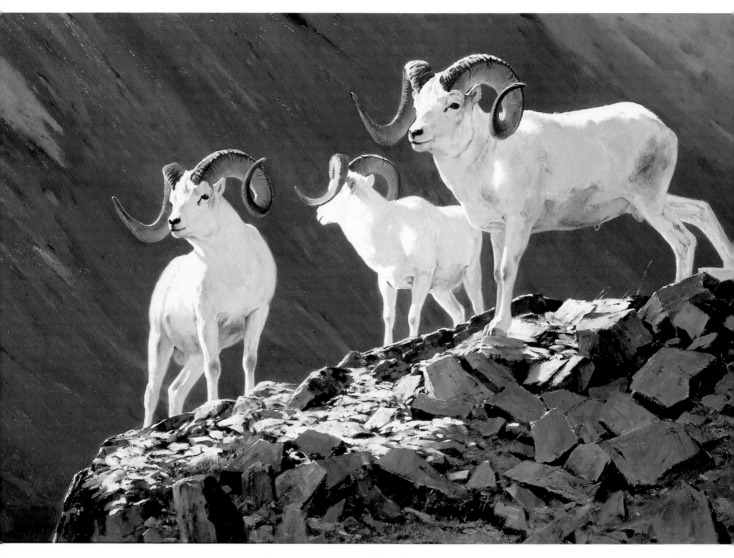

DALL RAMS

1982, oil, 24" × 36" (60.9 × 91.4 cm).

Dall Rams is basically a brown and white work, but the strong colors in the browns and whites make the painting jump. Ken Carlson got the idea for it while observing Dall sheep in the Alaska Range of Denali National Park. He was struck by the contrast between the white animals, standing in bright sun, and the dark rock slides behind them, and wanted to recreate the feeling of late afternoon light filtering between the peaks, which gave the horns of the rams a soft salmon glow.

To establish the tone, Carlson first scrubbed the entire surface of a Masonite board with a dark mixture of Van Dyke brown, alizarin crimson, and ultramarine blue, thinned to a wash with turpentine. Colors tend to slide around on Masonite, staining the surface in a varied and interesting way, and Carlson lets a lot of this texture show through. After the initial coat had dried, the artist roughed in the values, working back and forth from dark to light and light to dark and using yellows and reds throughout the painting to keep

it warm. Using a large brush and lots of pigment, he then finished painting the background with a mixture of veridian, burnt umber, and burnt sienna. Carlson then did the rams and the foreground rocks, using all the foreground colors in the shadows of the sheep—cobalt blue, ultramarine blue, permanent green light, veridian, raw sienna, and raw umber, with Naples yellow in the highlights.

"If the sun were full on the rams, they would be bright white, and I didn't want a pure white animal," says the artist, who frequently backlights his subjects for more interest. "By picking up all the colors in the landscape, I was able to reflect them into the bodies of the sheep as shadow color."

The sheep are shown from below, and large in proportion to the paintng, which creates a more dramatic composition. To further emphasize the stark contrast, Carlson shows no sky. Field sketches and photographs taken on the spot supplied the primary reference for the work.

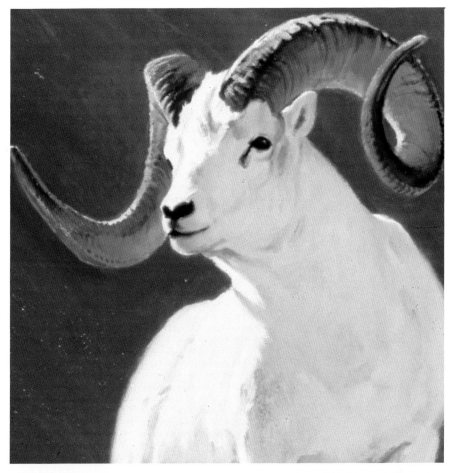

The white animal can be a colorful subject if it is backlit and built up with shadows that reflect the hues in its surroundings. The close-up of the ram's head at left contains white, Naples yellow, veridian, raw sienna, and cobalt blue, with burnt umber and cobalt blue in the deepest shadows. Carlson used a lot of yellow ochre, Naples yellow, and raw sienna in the horns, then warmed them with some vermilion to create a pinkish tan. The horn shadows contain vermilion and cobalt blue. The ram's head was worked over three or four times, light to dark and dark over light as the artist gradually intensified the underlying color values and added detail.

The shapes and color values of the foreground rocks were laid in at the underpainting stage, freehand. Carlson went back in to soften some edges and define others, but left many of the initial passages untouched, to retain a spontaneous feeling. To anchor the animals to the rocks so that they wouldn't appear to be floating, the artist highlighted the rocks with white, laying it in with heavy brushstrokes to create an interesting texture.

LOSING EDGES TO AVOID A SILHOUETTED LOOK
Ken Carlson

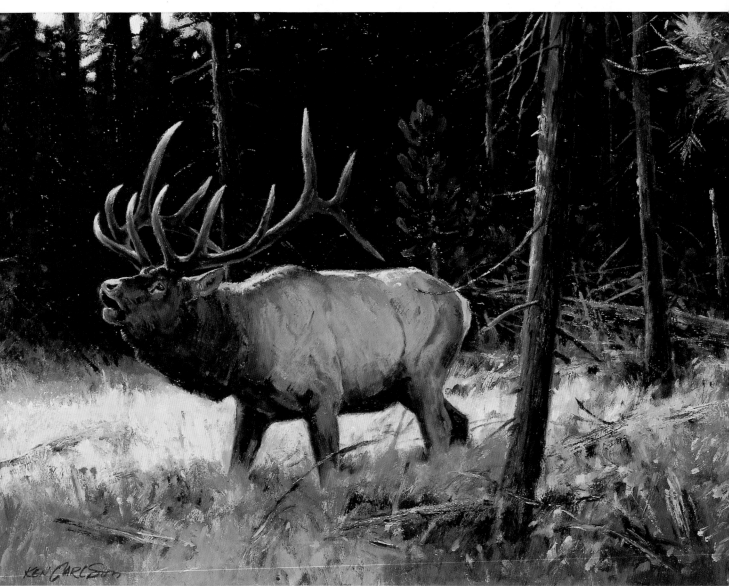

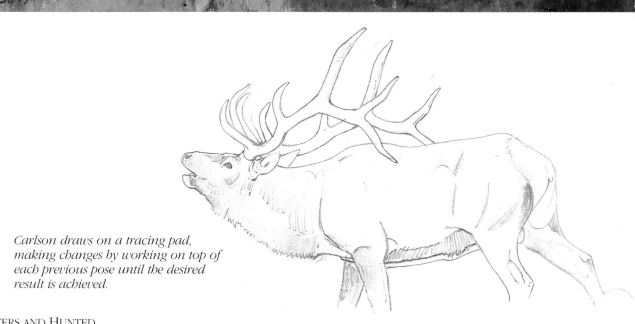

Carlson draws on a tracing pad, making changes by working on top of each previous pose until the desired result is achieved.

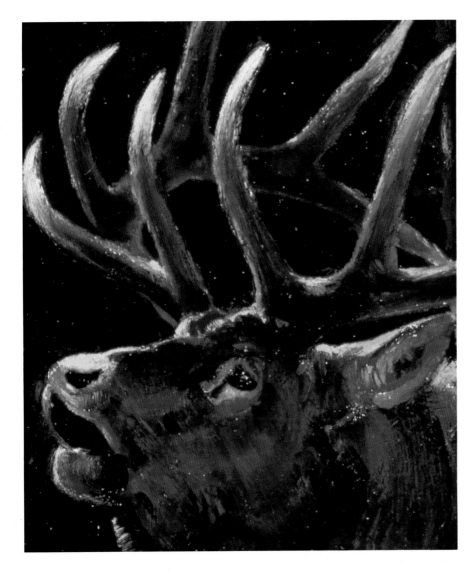

BUGLING ELK

1982, oil, 13" × 18" (33 × 45.7 cm).

"There always seems to be tension in the air when the mountains resound with the bugling of bull elks looking to do battle. They can be very dangerous in the fall when they're in the rut and one must be cautious when approaching them," says Ken Carlson, who was once attacked and almost killed by one of the animals. Despite the small size of this painting, the artist was able to capture the commanding presence of a bull elk by making the animal large in proportion to the overall format. Its legs are firmly planted, and the bold brushwork helps to convey an impression of power.

The elk both stands out and blends into the landscape. Its head and back are outlined with light against the dark trees, while its neck and undersides are shown dark against the bright grass. Where there are strong shadows in the background and the elk, Carlson allows some edges in the antlers to merge with the dark forest. This avoids a silhouetted cut-out, pasted-on look, and allows the eye to fill in the detail.

The board was underpainted with tones close to the final work, thinned with turpentine to allow most of the pencil sketch to show through. Carlson then painted the background with a mixture of burnt umber, ultramarine blue, vermilion, and chromium oxide green. To avoid getting muddy colors, which can result when lighter tones are painted over very dark ones, he made certain that the paint was completely dry before adding the subtle middle tones and highlights in the trees and brush. The bright area in front of the elk's neck ruff has been softened and darkened gradually, so that it recedes instead of appearing as a hard line of light, which would make the background seem like a wall.

The foreground is a rich mixture of burnt sienna, raw sienna, yellow ochre, cadmium yellow light, burnt umber, cobalt blue, and titanium white. All of these colors are used to build the body of the elk as well, which reflects its surroundings. "There is a lot more color in an animal in shadow than when light is hitting it directly," says Carlson. "Backlighting a subject gives the artist a chance to put in every color of the rainbow." The artist referred to color photographs taken of the setting, but he removed some trees, rocks, and brush to accommodate the elk, and added foreground vegetation to complete the design. He also warmed the overall coloration to evoke a predawn atmosphere.

Arranging Elements in a Composition
Bob Kuhn

Run, Rabbit, Run

1975, acrylic, 20" × 36" (50.8 × 91.4 cm)

"This painting is typical of many where I arrive, after much doodling, at a workable arrangement of contending elements, and then put them into a plausible setting," explains artist Bob Kuhn. In this instance, he created the gestures of the coyote and rabbit, and then used all available scrap material to verify the details, such as coat variations and conformation. Scaling the drawing up mechanically to final size, he traced the animals onto tissue paper and moved them around the Masonite board until he found the right design.

The central bush, which seems to explode in all directions like a firecracker, provides a vortex around which the action swirls. Kuhn captures the character of the lunging coyote and fleeing rabbit with a few simple brushstrokes. He has given their heads detail and expression but has blurred the edges and lost detail in their hindquarters and feet to increase the feeling of speed. Similarly, the vegetation coveys the sense of place—southwestern scrubland—without precise delineation, which would "slow down" the composition. The artist's palette is spare, in keeping with the terrain. He has laid in the foreground plane roughly, with palette knife and sponge, to add interesting surface texture.

Although Kuhn is not a "hair" painter, he frequently uses a soft Wolff carbon pencil to indicate fur texture, finding that it adds a sharp gritty accent which cannot be achieved with a brush. Here, the coyote's ear tufts and some areas in the rabbit's coat have been enhanced with pencil squiggles, which were then sprayed with a fixative to prevent smearing.

Any number of sources can provide the genesis for a Kuhn painting—a few quick lines, an interesting photograph, the juxtaposition of colors in another painting, or even a magazine ad—but direct observation of the animal comes first. "Field work, to me, is the cornerstone of wildlife art," says Kuhn. "You can bend the knowledge you've accumulated to advance the aesthetic aims of your painting, but you'd better have the knowledge first. Facts are the start of the journey; truth is the object of the journey."

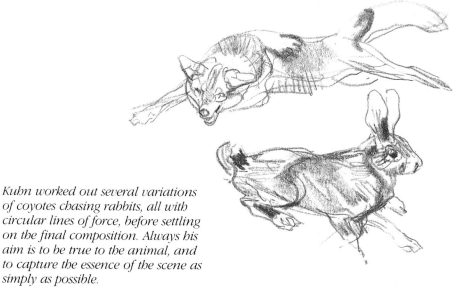

Kuhn worked out several variations of coyotes chasing rabbits, all with circular lines of force, before settling on the final composition. Always his aim is to be true to the animal, and to capture the essence of the scene as simply as possible.

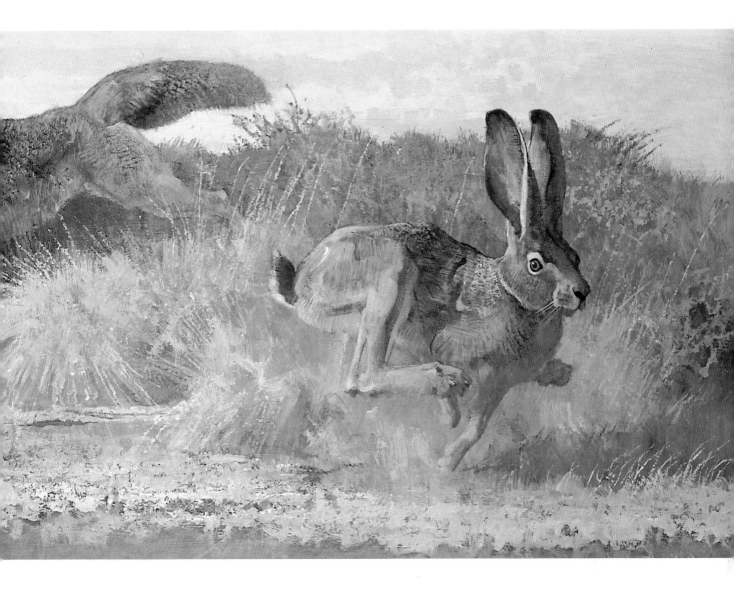

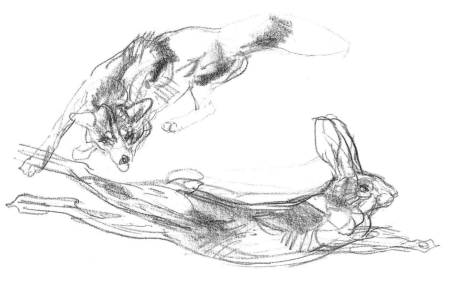

THE IMPORTANCE OF UNDERSTANDING ANIMAL BEHAVIOR
Ken Carlson

DAWN'S EARLY LIGHT

1984, oil, 24″×36″ (60.9×91.4 cm).

Placing a familiar subject in an unusual setting can result in a painting with particular appeal. Here, a shaded arroyo, or washout, relieves the monotony of the South Texas scrubland, and provides a backdrop for a pair of whitetail bucks. The light and shadow in the painting carry the interest.

"When putting two or more animals together, you must demonstrate an understanding of how they interact," says the artist, Ken Carlson. "In this case, the large buck would only tolerate the presence of a smaller buck as a fall traveling companion. Any knowledgable viewer would be quick to spot a behavioral flaw. Knowing animal behavior broadens the spectrum for painting ideas."

Carlson's range of colors was decided by the season, and his lighting by the time of day. The sunlit portions of the deer were painted with a mixture of raw sienna, yellow ochre, Naples yellow, and burnt sienna. Their shadows are indicated with raw sienna, vermilion, cobalt blue, and burnt umber. The artist laid in the dark side of the antlers first, to establish the play of light, emphasizing the sharp edges of the prongs to give them a feeling of hardness.

The muted vegetation is actually an array of colors, including chromium green oxide, vermilion, Naples yellow, cadmium yellow light, yellow ochre, burnt umber, and raw umber. The prominently located cactus at the top of the arroyo could have been distracting. By painting it in simple tones, with just a few, broad strokes, Carlson was able to convey its distinctive shape in a way that enhances the landscape without drawing attention from the deer.

To jog his memory, the artist often uses photographs he has taken of the subjects and the scene, and may refer to half a dozen pictures for various anatomical details. Carlson cautions, however, that an artist must learn to edit out photographic distortions, since the camera tends to flatten planes and foreshorten objects. "Field experience is the number one influence. It provides me with ideas for poses, settings, and mood. I see and feel things that a picture cannot capture, and my mind retains the essence of a scene—something I can't pick up from a photograph."

Carlson roughs out the pose of a subject on tracing paper, redrawing the parts he wants to change on overlays. Here, by shortening and thickening the neck, giving it a heavier body, moving the front legs apart, and extending the back one, he altered a young whitetail (right) into a bigger, more mature buck (far right).

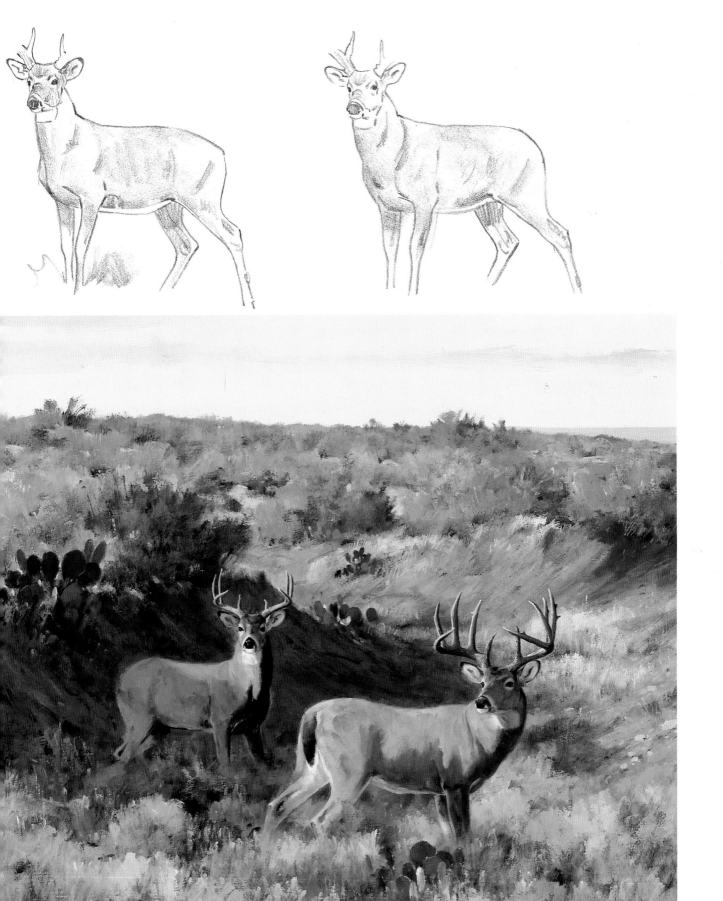

GROUPING ANIMALS IN THEIR NATURAL TERRAIN

Ken Carlson

SPRING ANTELOPE

1980, oil, 24" × 36" (60.9 × 91.4 cm).

Ken Carlson was prompted to paint this scene when he spotted a herd of pronghorn antelope browsing among sagebrush and spring wildflowers—a different setting from the golden-brown colors of fall with which they are more often associated. The natural landscape of the Wyoming prairie, with its rolling hills and distant buttes, determined the format. The contrast between the tan animals and the many greens in the painting was dictated by the season, the month of May, when the prairie is at its peak of color. To maintain the feeling of open expanse, Carlson kept the animals relatively small in relation to the landscape, painting those in the background with less detail to imply distance.

The grouping of the herd was deliberately planned. "I try to show varied poses so that the viewer won't get bored, and yet the arrangement must appear natural," the artist explains. "By placing the pronghorns in different positions, it was possible to sidelight some, while backlighting others, which breaks the monotony of having them all the same tone." Carlson worked out the herd's placement by moving around tissue tracings of one animal, shown in various attitudes, until he found a pleasing combination.

The artist began the painting at the top, establishing the atmospheric color first, then gradually darkening the values and increasing the sense of detail as he worked toward the foreground. He paled the distant buttes to convey a sense of heat, and to avoid distracting from the main subject. The scene is of midday, and so the artist used true colors, rather than the warmer tones of early morning or late afternoon light.

Carlson painted the vegetation with a mixture of cobalt blue, viridian, permanent green light, raw umber, and Naples yellow, using several shades to show the subtle variations in foliage. The antelope reflect the landscape colors, blending in just as they do in nature. In sunlight, their tan markings are raw sienna, yellow ochre, and Naples yellow; in shade, the tan is made up of raw umber, with a touch of permanent green light. The flanks of the pronghorns are actually more green than white, to reflect the sagebrush. "There is no such thing as shadow color," says Carlson. "Each work has to have its own tonality. In one of my paintings the animal shadows may be pinkish-gray; here they are gray-green. Always they reflect the hues of the particular setting." The quiet composition and muted colors of this springtime scene capture the feeling of peace that the artist often associates with herds of these gentle antelope.

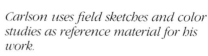

Carlson uses field sketches and color studies as reference material for his work.

EXOTIC BIRDS

Allen Blagden

Don R. Eckelberry

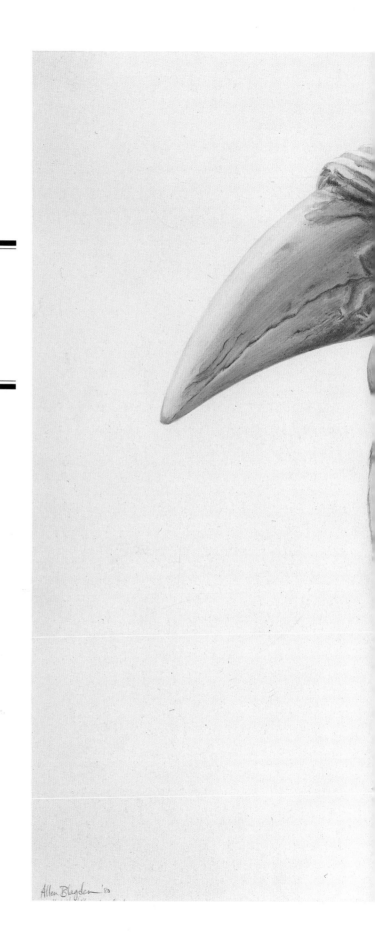

Allen Blagden '80

Allen Blagden, *Wreathed Hornbills*, 1980, 22″ × 30″ (55.8 × 76.2 cm).

Designing for Another Medium
Allen Blagden

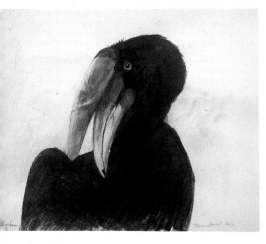

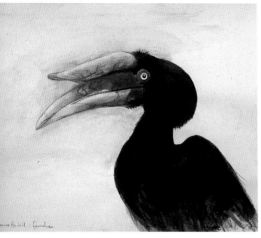

At first the format for each bird differed, but the artist decided that he wanted the hornbills to balance each other and so gave them a similar pose.

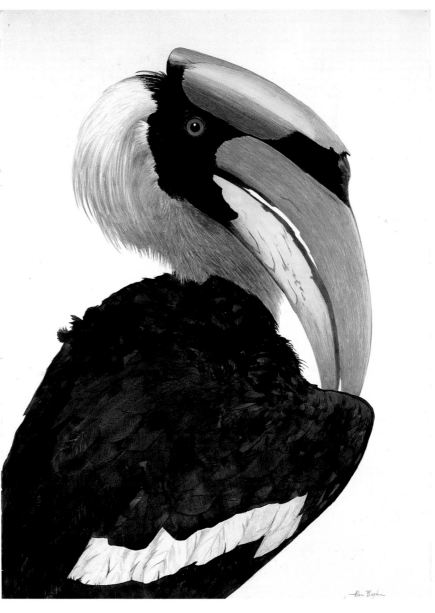

HORNBILL I

1980, watercolor and graphite, 22" × 30" (55.8 × 76.2 cm).

The painting of this male concave casque-billed hornbill, entitled *Hornbill I*, was approached with the idea that it would be translated into a lithograph, and so was deliberately restricted in color and format. The artist, Allen Blagden, needed a strong subject, essentially black and white, which would lend itself to a dramatic design. To emphasize the stark impact of its dark shape, he painted it in profile, almost flat, and more abstracted than he normally works.

"The design is really a series of complementary curves running down the page," Blagden explains. "I had the curve of the beak on one side, balanced by the curve of the head. The drooping shoulder made another curve. Also, I liked the white wing patch picking up the white on its head." After blocking out the silhouette, the artist built up the body of the hornbill with layers of Payne's gray. He experimented with its remarkable beak by allowing the pencil modeling to show beneath transparent washes of Naples yellow and cadmium yellow. The piercing eye is crimson lake; the dark on the head, ivory black.

The lithograph of *Hornbill I* required three pressruns. The first picked up the delicate pencil strokes on the bird's white feathers, beak, and eye; the second reproduced the rest of the feathers; and the third added the heaviest blacks. Each pressrun overlapped the next, building up transparent layers of texture. Blagden hand-colored the beak and eye for the entire edition, to save further press costs.

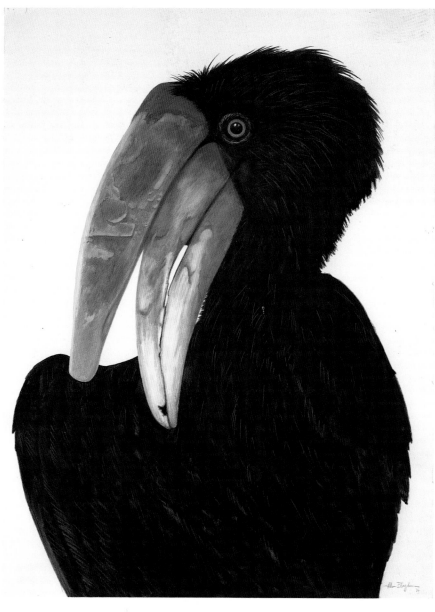

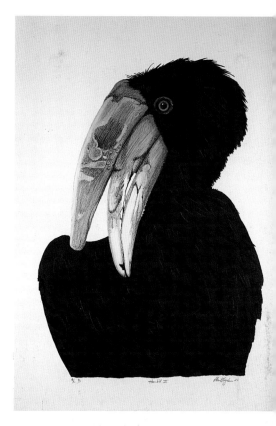

The lithographic version of Hornbill II *faithfully repeats the abstract design of the watercolor. The softly blended tones of the original, however, translate into a more linear, hard-edged pattern.*

HORNBILL II

1980, watercolor, graphite, and colored pencil, 22" × 30" (55.8 × 76.2 cm).

As with *Hornbill I, Hornbill II*, which depicts a male rhinoceros hornbill, was sketched at the Bronx Zoo, life-size, on a large newsprint pad. Later, Blagden transferred the drawing, by means of tracing paper, to the final surface—a sheet of Arches 140, hot-press paper. He penciled in the shading on the bird's beak, then laid several transparent washes over it, consisting of Naples yellow and an orange made up of cadmium yellow mixed with scarlet lake. The hornbill's body was painted with washes of Payne's gray and ivory black, to which Blagden added strokes of blue colored pencil, giving the effect of light iridescent highlights.

For this lithograph, which required only two plates, Blagden first traced the beak and eye onto a Mylar sheet, then reversed the image and redrew it on a zinc plate, with a black lithographic crayon. At this stage, he used a mirror to view the work in the same direction as the original watercolor. The process was repeated with the hornbill's body, which was brushed onto another plate with a black greasy liquid called tusche. The images on both plates overlapped to make the final print, which reversed the subject once again so that it reproduced the original work.

The first pressrun used dark blue-gray ink to pick up the deep color of the body. On the second run, slate gray ink was rolled on the plate to reproduce the delicate pencil details of the beak and eye. The artist then handcolored the beak, eye, and blue pencil strokes in all of the prints.

Laying in Washes to Build Color and Form
Allen Blagden

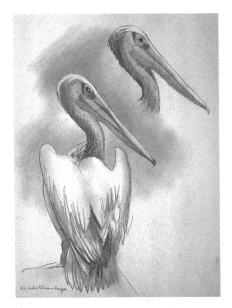

A preliminary drawing clarified that the pelican's shoulders were crucial to the overall composition. Later, they were sketched in first.

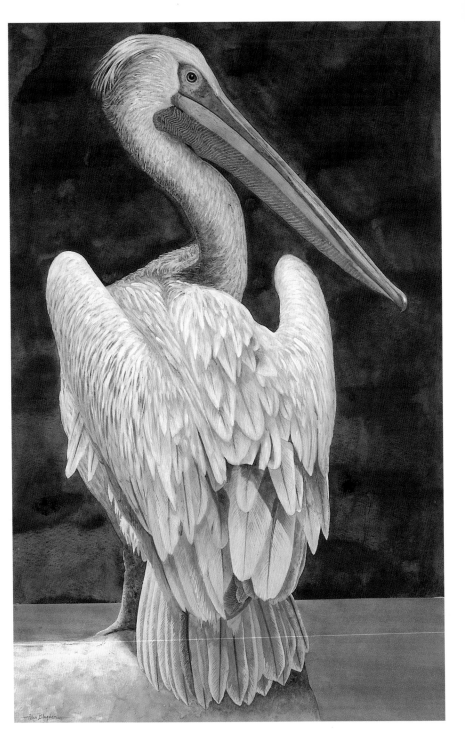

Moon Pelican

1983, watercolor, 26" × 40" (66 × 101.6 cm).

Allen Blagden's interest in painting birds often lies more in capturing their spirit than in detailing the form and coloration of a specific species. Although these portraits were inspired by African birds, the artist transformed them into generic works that are Audubonesque in scale and design.

The artist juxtaposed the curves of the bird with the straight line of its bill. He felt that its pouch would be too dominating if shown fully extended, but he was fascinated by its ridges and painted them in detail. The bird's structure was built up with tones of Davy's gray, as well as some soft pink and Payne's gray, over pencil shading. Blagden creates pink from a very pale wash of scarlet lake or a mixture of Naples yellow with minute amounts of scarlet. The bill is mostly Naples yellow, with a bit of yellow ochre. Before applying the dark background, Blagden masked the pelican with rubber cement. He then mixed up a large batch of Payne's gray and burnt umber and applied it heavily, with a large brush, tilting the paper up and down so that the color flowed over the entire surface. After letting it dry flat, Blagden added another wash to further darken the final color.

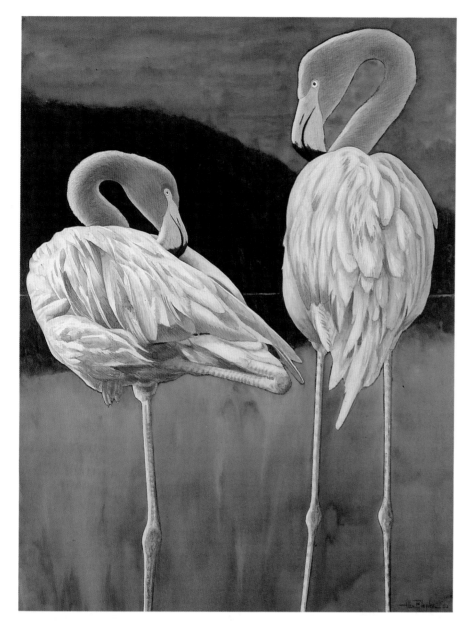

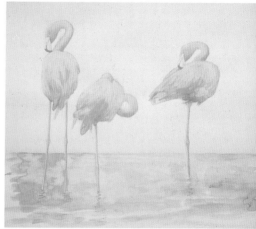

The artist experimented with the placement of the birds and the basic color scheme before proceeding with the final work.

FLAMINGOS II

1980, watercolor, 22" × 30" (55.8 × 76.2 cm).

In *Flamingos II*, Blagden wanted to convey the awkward elegance of a bird that is basically beautiful but ungainly at the same time. "Flamingos are formal, which dictated the design," he explains. "I liked the pink and the fact that the uniform color allowed more focus on their shapes, which is the primary point of the painting." He chose to show the birds preening, using the curve of their necks and outer curve of their bodies, balanced against each other, to contain the visual images within the boundaries of the paper. The structure of their legs added strength. Three or four washes of pale scarlet lake, applied over pencil shading, built up the bodies of the birds. Small amounts of Davy's gray were added here and there to model the feathers which, like the pelican, were painted individually. The bills of the flamingos are yellow ochre, tipped with ivory black.

Blagden decided to have the flamingos stand out like silhouettes against the dark background, and was able to maintain a crisp edge by painting them first. Had he started with the background, he would have had to carry the wet pink up to the edge of the gray, which would have bled into the birds. "When you paint a big wash like this, the trick is to get consistency throughout," says Blagden. "I mix up what I think will be enough color to cover the whole area and then, when I tilt the paper, it will run smoothly. It has to be done very fast. If I run out of color and have to make another batch, the first part will have dried and the effect will be uneven." Blagden used a large brush right up to the line of the flamingos' legs, filling in the narrow gap with a finer brush. He controlled the dripping effect by working with a wet wash on dry paper. Toward the end of both paintings, the artist lifted off some paint with a wet brush and tissue to create a strip of horizon, which put the birds into an environment.

CROPPING TO ADD IMPACT
Allen Blagden

BATALEUR EAGLE

1983, watercolor, 22" × 30" (55.8 × 76.2 cm).

Allen Blagden found a unique opportunity to study a Bataleur eagle close-up, in perfect plumage, by working with a pet owned by a friend in Kenya, Africa. As he sketched it, the bird was perched on a gloved hand, with its wings outstretched for balance. The artist did not trust the intentions of the intelligent creature, and respected her immensely. To convey her immediate wild power, he decided to paint a head-on view. The artist deliberately had the wings extend out of the picture at midpoint, and foreshortened the body to stress the feeling of confrontation. The eagle's head is almost at the center of the composition, at the cross point where the feet and wings meet, and its eye contains a piercing highlight that gives it a riveting intensity.

The upper curves of the bird press it down while the curves under the wings lift it up, contributing to a feeling of perfect balance and near-weightlessness. Blagden also wanted to emphasize the talons, and succeeded in conveying the feeling that they were just touching something solid, but that the eagle was poised for instant flight. The bird's beautiful color pattern is part of the design and composition. Its bright beak and talons, painted with pale washes of scarlet lake, are in sharp contrast to the rich, dark plumage. Its body is built up with washes of Payne's gray, with lighter Davy's gray used under the wings, and its back a mixture of burnt sienna and warm sepia. To keep the feather edges crisp, each is painted individually, the form built up with dark tones. To create a sense of atmosphere, Blagden threw in a very faint wash of Payne's gray in the background, just enough to go a step beyond the whiteness of the paper.

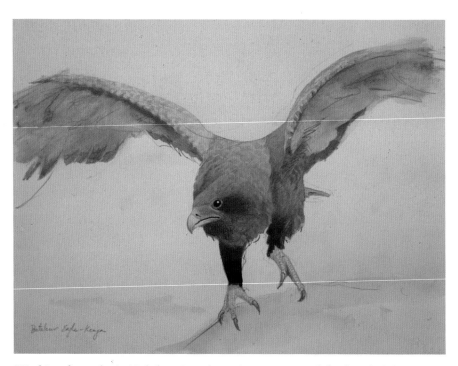

Working from the initial drawing, the artist repositioned the feet slightly and cropped in on the eagle for a more dramatic composition in the final work.

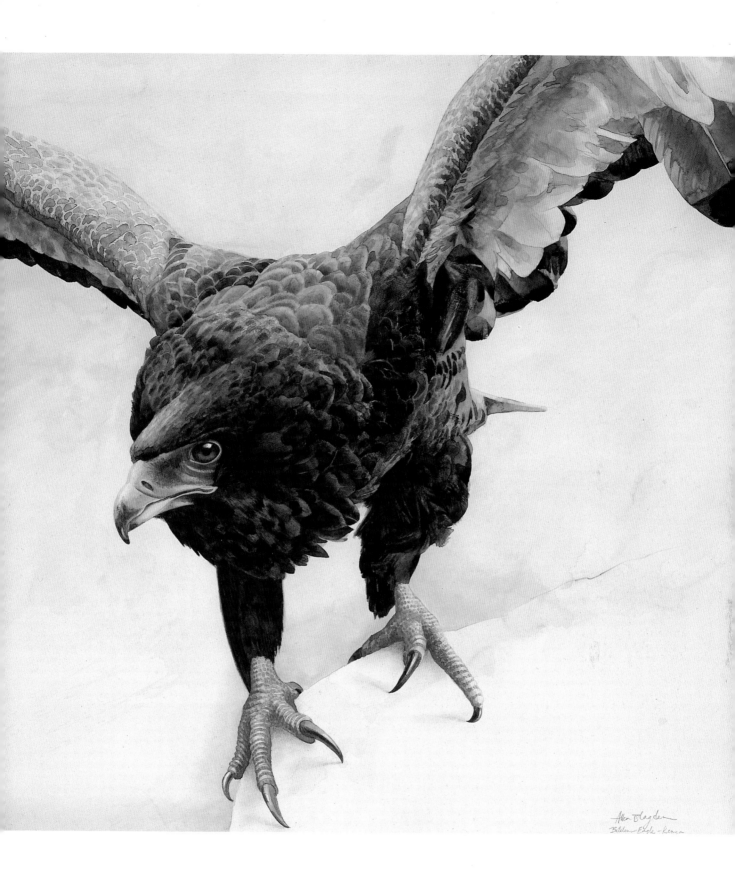

Allen Blagden
Bateleur Eagle – Kenya

PAINTING CRISP FEATHERS WITH WATERCOLOR
Allen Blagden

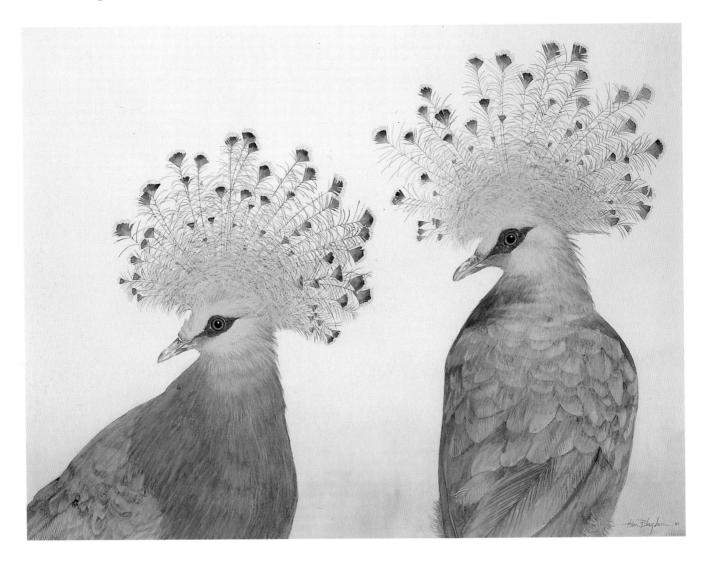

VICTORIA CROWNED PIGEON

1980, watercolor and gouache, 30" × 22" (76.2 × 55.8 cm).

Allen Blagden's work is noteworthy for the remarkable handling of feather structures and detail. The unique headdress of the three-foot-tall Victoria crowned pigeon was the inspiration for his portrait of these birds, which were painted from life as Blagden sat inside their winter quarters at the Bronx Zoo. The artist looked at the subject purely as design, wanting two shapes that repeated each other, in profile. He cropped their bodies to further draw attention to their extraordinary heads.

The delicate crown feathers were painted with a number 1 sable brush, in designer's gouache gray number 1 as well as some transparent Payne's gray, Winsor violet, and a bit of cerulean blue. The artist allowed each area to dry thoroughly before adding more pigment. The pigeons' bodies were first shaded in graphite, then built up with layers of Winsor violet and transparent Davy's gray, and overpainted with designer's gouache gray number 1 to capture the feeling of the soft, pearly colored plumage. Blagden has strengthened the subject here by keeping the background simple, adding just a slight wash to establish the hint of an environment.

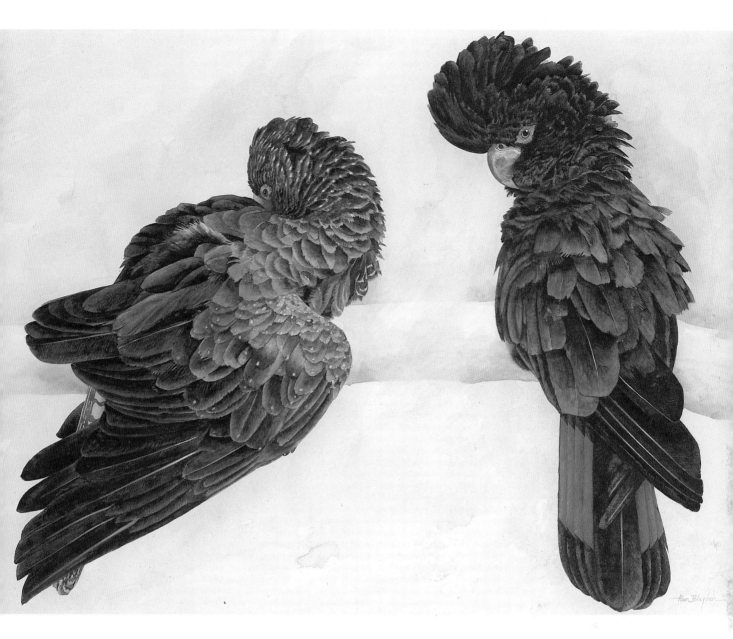

BLACK COCKATOO

(1981), watercolor, 30″×22″ (76.2×55.8 cm).

In *Black Cockatoo*, Blagden challenged himself with depicting form in a mono-chromatic shape. Here, the feathers of the birds stand out as almost tactile structures. To maintain their crisp edges, the artist painted each overlapping feather separately, allowing it to dry completely before going on to the next one. The male on the right is done almost entirely in Payne's gray. Blagden first laid in a medium wash, then went back with dark tones, carefully leaving a thin line of the original wash down the middle of each feather to indicate the central vane. When the feather was still wet, the artist tipped the paper at an angle so that the wash would dry darker toward the base of the feather, increasing its density. When he had finished, Blagden went back over the plumage, darkening some areas and lightening others by elimination. At no time did he use opaque paint. The sides of the male cockatoo's tail are bright Winsor red. The female's plumage is a mixture of Payne's gray and burnt umber. As the artist painted each of her feathers, he left a small space for the speckles at the tips, adding them last with dots of cadmium yellow.

Blagden painted these rare cockatoos at the San Diego Zoo. "I loved the pair of them," he says. "It was very hot and the female was completely relaxed, with one wing down. The male was watching me paint him and seemed to be actually posing. I wanted to convey the quality of his alert observance."

CAPTURING A PARTICULAR BIRD'S CHARACTER
Don R. Eckelberry

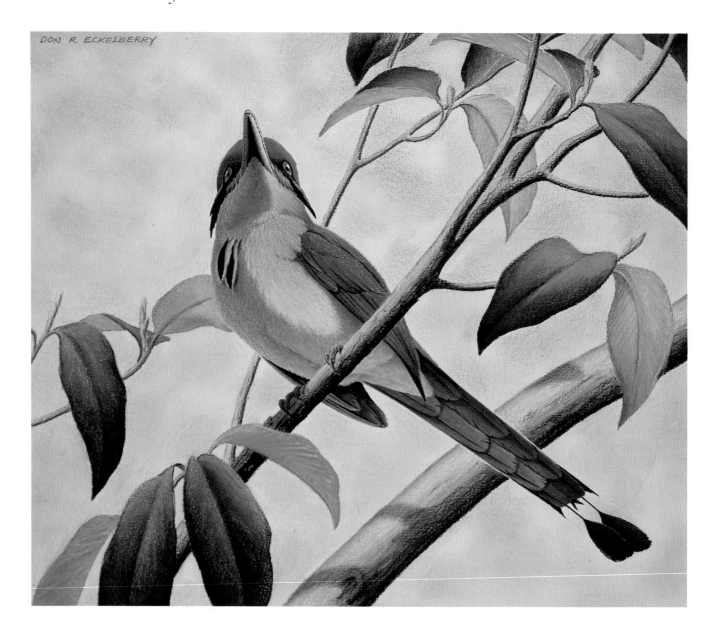

RUSSET-CROWNED MOTMOT

1957, watercolor and colored pencil, 10" × 14" (25.4 × 35.5 cm).

Don Eckelberry, who has been painting birds professionally for the past forty years, continues to experiment with many different surfaces and media. "I think it's very important to be open and try new things," says the artist. "We all develop clichés and habits and it's good to be aware of them, to put them aside, and to strike out in some new direction." Eckelberry's approach to the subject matter is original as well.

The Russet-crowned Motmot is shown in a pose that is unusual but one that the artist thought was expressive of the bird's personality. While not suitable for a field guide, it captures the character of the motmot in a way that a straightforward portrait could not. Eckelberry painted it in the studio, from a museum skin and from field sketches made in Mexico, based on countless hours of observation. The artist was interested in exploring the possibilities of colored pencil and wash. Using black watercolor, he laid in a gray wash, like a halftone, and then applied colored pencil on top of it for a textured effect. He worked primarily from light to dark, wiping one color on top of another, taking care not to build up the layers too thickly. Here and there, the background was smudged with his thumb, to blend it.

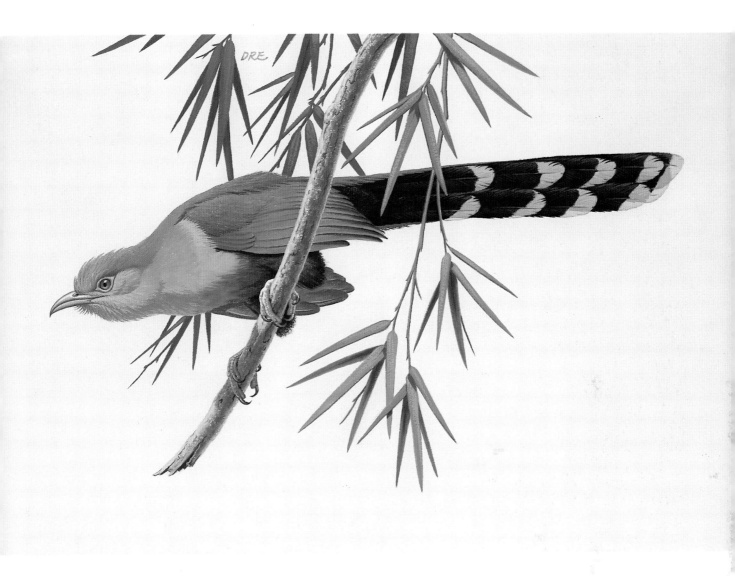

SQUIRREL CUCKOO

1975, gouache, 8½" × 12½" (21.6 × 31.8 cm).

The squirrel cuckoo is a rather large bird, common in Trinidad where Eckelberry painted it. It is portrayed in a hunched posture, typical of its curious way of moving through the trees, which may account for its name. The hanging leaves are as important to the bird as the design.

The work was done on Whatman board. The bird was painted almost entirely in opaque designer's gouache, to capture its chalky coloring. The artist used highly modified colors, with a lot of white. Since designer's gouache hardens rather quickly, the tubes were squeezed out only as needed. "For a decorative portrait like this, I paint one area, then another, because I know how it's all supposed to look together. I have that in my head," says the artist. "If this were a more painterly work, with a finished background, I would work over the whole picture simultaneously."

The bird's upper parts are a mixture of white with several browns, including Indian red and raw sienna. The gray and black of the underparts, feet, and tail are mixes of black, white, and a touch of blue. To get brilliance where needed, Eckelberry used transparent red for the eye and sap green for the eye ring and bill. Portions of its tail are somewhat translucent, with opaque texturing for definition. "You should use anything you can to get an effect," says Eckelberry. "Since colors do not have the range of light, you have to force things. Don't be afraid to compensate, distort, to go beyond." The artist notes that the general tendency for a beginner is to show birds clutching branches in a "death grip," whereas they are actually more relaxed and confident. Here, the squirrel cuckoo's toes hang over the branch loosely.

DRAWING BIRDS
Don R. Eckelberry

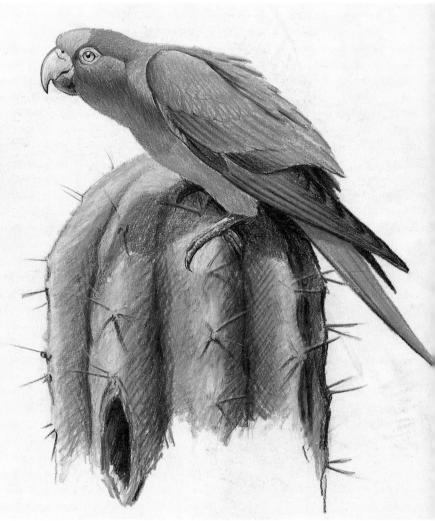

The artist captured the brilliant hues of an Amazona *parrot's head with colored pencil.*

This orange-fronted parakeet was a pet that the artist used as a model for a similar species shown on page 61.

BIRD SKETCHES

Colored pencil on tracing paper

"In my illustrational work, the drawing stage is the most important phase, the part on which I usually spend the most time," says Don Eckelberry, who often sketches several variations on a single theme before he is satisfied. The artist begins roughly, with a soft pencil on tracing paper, then puts another tissue over it and traces off, adding to the best features of the sketch. More layers follow until he achieves a final working drawing. The tissue is then flopped and traced onto the painting surface.

Most of Eckelberry's work is done on cold press Whatman board. For greater portability in field work, the artist uses the same paper, in glue-bound blocks.

In the field, Eckelberry tends to do more color note-taking than sketching, finding that when memory of the visual experience fades, accurate written descriptions are more useful. However, when working in the tropics, where birds are frequently high in the jungle canopy or hidden by dense foliage, the artist often captures his subjects in Japanese mist nets, which he sets out early in the morning. While waiting for whatever comes in, Eckelberry spots a bird on the page and pencils in a temporary branch. He keeps his subject in a large glass-fronted, screen-topped box, occasionally taking it out to check measurements and examine it

more closely. Having a live bird gives the artist something more vital and immediate than a specimen or a study skin. To save it as much stress as possible, he works rapidly, painting the bird the same day and releasing it before dark, then completes the appropriate background the following day.

Pointing out some of the more common errors in drawing birds, Eckelberry comments, "When the bird is in three-quarter view facing out or into the picture, the distance from the eye to the bill is increased, not foreshortened in perspective, because the eyes and bill are in different planes. The width of the skull sets the eyes out beyond the center of the skull line. Equally important is the way the eye is set; it is not just flat against the plane of the head." The artist also stresses that the thickness of a bird's legs varies from head to toe; they are not properly described by two parallel lines. Showing the correct number of toes and their positions in front of a branch or behind is equally important, as is depicting the correct number of feathers and the proper overlapping arrangement of the plumage, if such precise delineation is the goal. Finally, Eckelberry urges visual logic in combining background with foreground, to avoid extremes such as painting a mountain range behind a tiny sparrow.

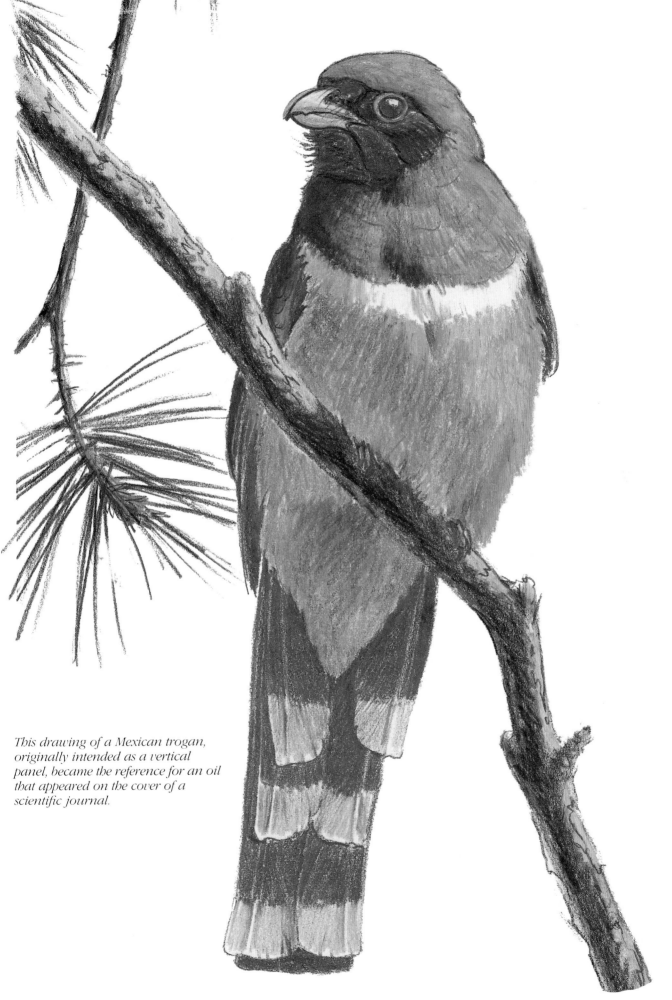

This drawing of a Mexican trogan, originally intended as a vertical panel, became the reference for an oil that appeared on the cover of a scientific journal.

PAINTING GREEN PLUMAGE
Don R. Eckelberry

TROGONS, PARAKEETS, AND KINGFISHERS OF THE WEST INDIES

1959, watercolor, 16" × 23½" (40.6 × 59.7 cm).

The illustration of bird guides requires artistic skill, scientific knowledge, and, wherever possible, firsthand familiarity with the species shown. Don Eckelberry, who has painted more than 1250 subjects for various books, including the *Audubon Field Guides*, was the first to break away from the flat profile approach and use shadow to create form. This plate was painted for a field guide to the birds of the Caribbean, in which the artist had a specific number of birds to portray, within a fixed number of pages. Since the emphasis is on recognition, each bird is shown to scale and positioned to display its most prominent traits.

Eckelberry arrived at the layout by moving around tissue drawings of the birds until he found a pleasing balance. He then outlined them on a sheet of tracing paper cut to working size, flopped the tissue, and retraced the birds onto the painting surface, their positions now reversed. By working in this manner, Eckelberry was able to maintain the quality of the original drawings and compositional balance, and keep the final surface clean. The birds were painted lifesize, to avoid having to rescale them all proportionately later.

The greens in the birds' plumage were painted with various mixtures of veridian and Winsor emerald, although Eckelberry generally stays away from such intense hues unless he needs a potent effect, typical of the coloration of many tropical species. Occasionally the artist will use modified tube colors such as sap green, and Hooker's dark and light green, but he prefers to create his own out of yellows, blues, and browns. "Green out of the tube is too raw and there is a tendency to be influenced by the violence of the paint," says Eckelberry. "Nature is not like that. Greens come in many shades—ochre-green, blue-green, olive-green, and so forth. It's better to get the effect you want by mixing a variety of colors." When illustrating field guides, the artist compensates for the inevitable loss of quality in reproduction by making the paintings as strong as possible, even exaggerating some elements to get a truer result.

Eckelberry outlines each bird in pencil, defining its plumage pattern but preferring to indicate rather than carefully delineate the actual feathers.

THE AFRICAN PLAINS

Robert Bateman

Guy Coheleach

Bob Kuhn

John Seerey-Lester

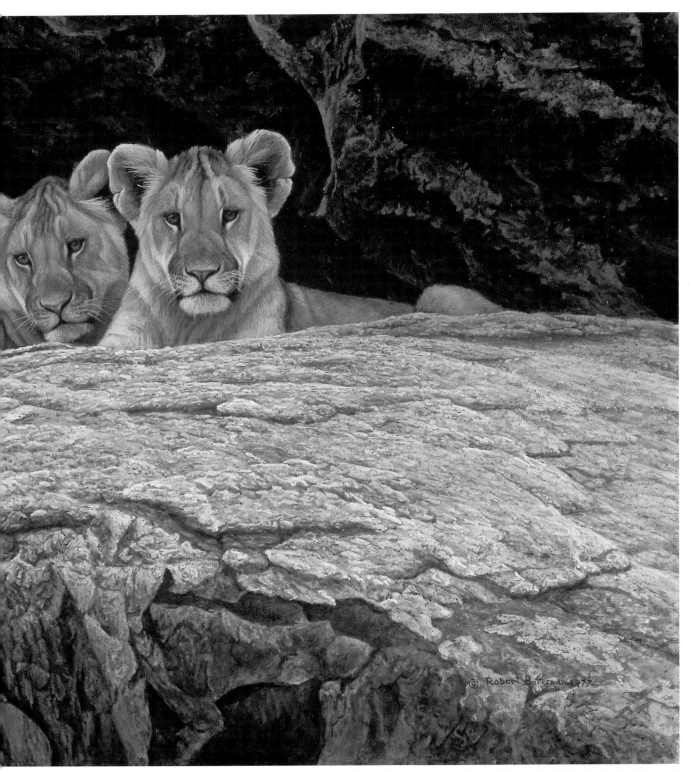

Robert Bateman, *Lion Cubs,* 1977, acrylic, 24″×36″ (60.9×91.4 cm).

CONVEYING A FEELING OF ACTION
Robert Bateman

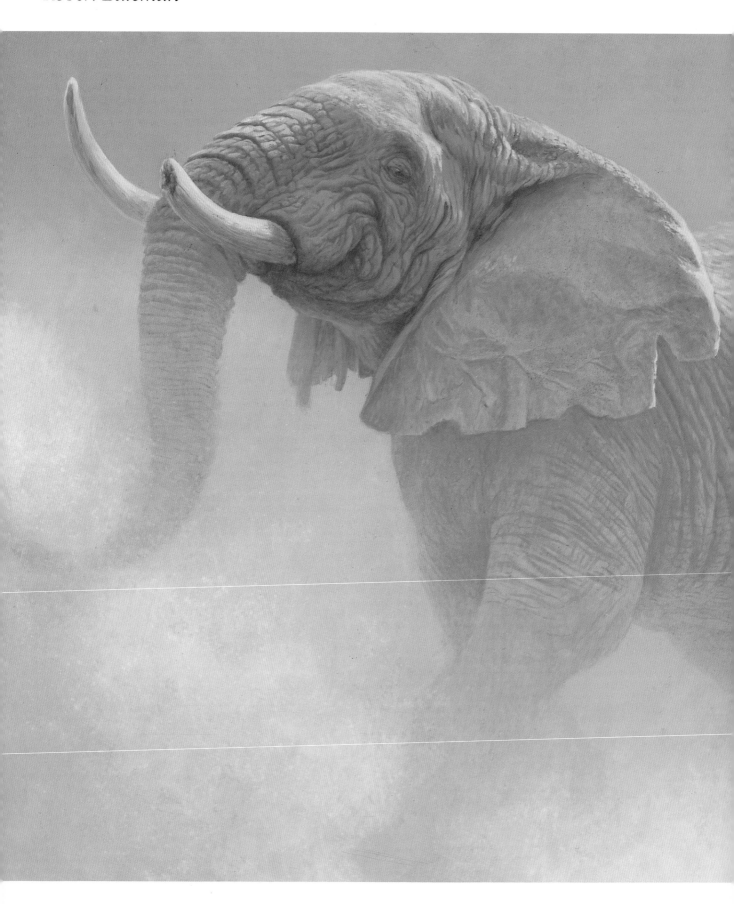

BLUFFING BULL—AFRICAN ELEPHANT

1979, oil, 24" × 39" (60.9 × 99.1 cm).

An old bull elephant has interrupted his charge and stands snorting in a cloud of dust. His sideways stance indicates that his threat is half-hearted and that he hopes to turn away the intruder with a display of power.

Robert Bateman did the painting from a clay model of a one-tusked elephant and a series of photographs he had taken in Amboseli National Park, Kenya. He managed to capture the particular animal's expression and character so exactly that a biologist was later able to identify it as one she had been studying, even though the artist had added a second tusk.

To emphasize the dramatic confrontation, the elephant was painted large and close-up, almost filling the frame. The very limited range of colors—yellow ochre, ultramarine blue, burnt umber, and white—simplifies the elements and emphasizes the flatness of the scene. Bateman treated the elephant's massive frame like a mountain rising out of the atmosphere, hazy at the bottom and getting sharper toward the top. To convey the feeling of action, the bull appears to be floating, not really attached to the ground or the frame.

Working on a Masonite panel, which had been sized with several applications of gesso and sanded down between coats, Bateman roughed out the painting right on the board, without any preliminary sketches. The artist explains, "I start out just trying to capture the action and composition, and I splash the paint down using fairly bold gestures to get the main rhythms and elements." He painted the elephant in detail first, then pushed it back with opaque oil glazes applied with a sponge. "Elephants represent a sort of landmass," says Bateman. "The wrinkles and hollows of the skin resemble hills and valleys. Every square inch of an elephant is a different texture, a different type of wrinkle, or a different quality of surface." The shrinking and swelling background areas provide strong, clean negative spaces against the interesting positive shapes of the elephant itself.

Bluffing Bull *was derived from thumbnails of various standing animals; the artist's imagination supplied the action.*

For Bateman, the eyes capture the character of an animal and are always considered first. Here, he works out the placement of an elephant's eyes in relation to the surrounding folds of skin.

ON LOCATION COLOR STUDIES IN PASTEL
John Seerey-Lester

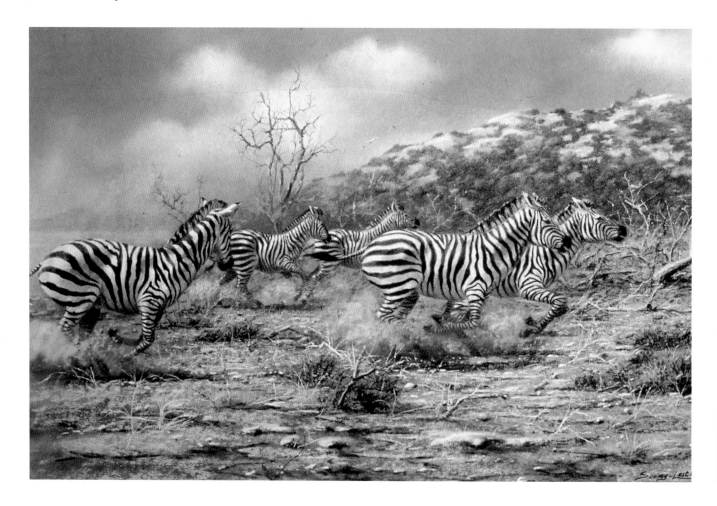

RUNNING FROM FIRE

1979, pastel, 15" × 20" (38 × 50.8 cm).

When in the field, John Seerey-Lester finds it easier to do color studies in pastels rather than watercolors. He first makes a very quick sketch, just enough to get the shape and note the colors, then does a finished pastel back in camp, which may take four or five hours to complete. Many pastels later become references for oil paintings.

Seerey-Lester prefers a rough-surfaced watercolor board to pastel paper, often allowing its texture to show through. He keeps a hundred different hues on hand, since it is not possible to mix the colors on a palette the way one could with oils. Working light to dark, the artist first blocks in the main subject and the background, blending the colors with his fingers. At this stage, the pastel looks like a blur. As he builds layer upon layer of color, the work becomes more defined, although it will never have sharp detail. Between each stage, the surface is sprayed with a fixative, which prevents smudging and enables him to continue working on top of the colors already laid down. He may spray a pastel fifty times before he is finished with it, picking out the highlights again after each application.

In *Running from Fire*, Seerey-Lester wanted to show the swirling dust and action of zebras stampeding across the African plain. At first, the animals looked like white horses on white paper, then shadows were added by mixing blue pastel with yellow ochre, Naples yellow, and a touch of flesh pink. Spraying the surface with fixative after each step, Seerey-Lester then blocked in the background, and added the zebra's dark stripes with a Van Dyke brown and a bit of blue.

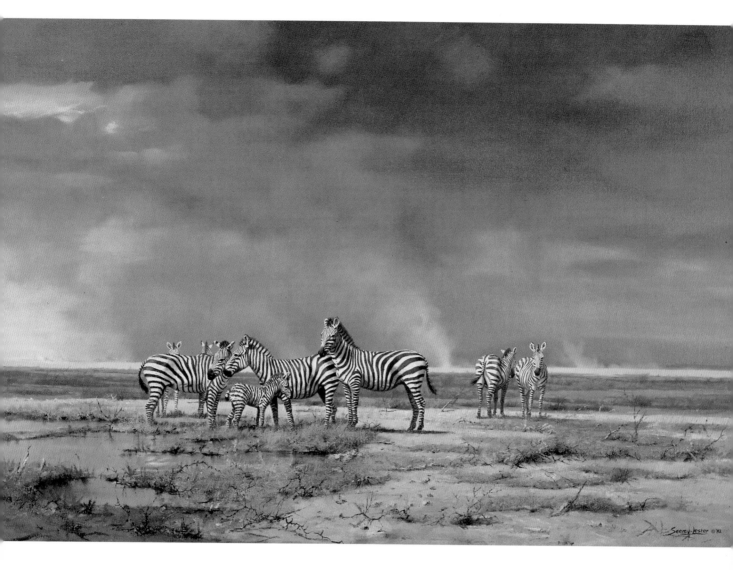

BEFORE THE RAINS—ZEBRA

1982, oil, 24" × 30" (60.9 × 76.2 cm).

The oil painting *Before the Rains—Zebra* was based on a number of pastel sketches. It was inspired by the time in Africa just before the rainy season when the hot sun contrasts with the darkening sky and sandstorms often appear on the horizon. The zebras were painted first, with white and a bit of Naples yellow, then their shadow areas were laid in with flesh pink and cobalt blue, to which a touch of yellow was also added. The artist advises that, although shadows on white objects are normally thought of as being blue-gray, they should include some yellow if they are reflecting a sunlit surface. To prevent the combination of yellow and blue from turning greenish, Seerey-Lester always adds a touch of flesh pink.

The zebra's stripes are burnt umber, mixed with ultramarine blue in the darkest areas and white in the lighter areas. The artist was careful to paint the young animal's coat shaggier, with browner stripes, just as it appears in nature. The sky was done with Payne's gray, neutral gray, ultramarine blue, and flesh pink, which Seerey-Lester blended together with his fingers, to give a softness to the clouds. To get a sense of light and shade in the foreground, he used a fan brush and dragged white, then flesh pink across the canvas from the sunlit side, and cobalt blue and pink from the opposite direction, for a lilac effect. The grasses were put in last, with yellow ochre and cobalt blue.

Painting Wild Grasses
Robert Bateman

Cheetah with Cubs

1978, acrylic, 21" × 27½" (53.3 × 69.8 cm).

Nestled in tall grasses on the African plain, an alert cheetah watches for predators. A closer look reveals the reason for her concern—two nursing youngsters lie almost hidden in the thick vegetation. Their slightly darker fur, with long white hairs, indicates that the cubs are newly born. By showing just their backs, the artist has resisted the temptation to portray them as cute, preferring to emphasize the dignity of the adult, whose intense expression provides the focal point for the picture.

A single green plant in the upper left corner is the only dissonant color in this rich harmony of yellow golds and browns. Seemingly unimportant, it provides an essential element in that it balances the mass of the cheetah and creates a tension in the direction of her gaze. The grasses form a frame for the subject but also extend out of the picture along the edges, as though they are meant to continue on as part of a larger landscape.

Bateman began by painting in loose and slashy areas with yellow ochre, which he broke up into darker long, jagged triangles. These he sliced with lighter strokes again, and then toned down the entire surface with a glaze of yellow ochre mixed with burnt umber. Individual grass blades were handled in much the same manner. The first stroke, a mix of yellow ochre and white, was darkened with a yellow ochre glaze. Then the tip was highlighted and the whole blade glazed again, further darkening its base. Finally, the very tip was painted pure white, with a touch of clear yellow, giving the finished blade a light-medium-dark tonal range from tip to base. Slivers of bright green, blue, and orange were added here and there for accent.

When the details were completed, Bateman stepped back to view the result. "I had all these blades of grass singing out triumphantly and I couldn't see the woods for the trees," he says. "So I killed the whole bunch of them with a transparent wash, highlighted just twenty-five or thirty tips which I had folded over, and let these play like passages on a flute." In the finished work, the grasses form a lyrical light yellow tracery across the entire picture.

Bateman meticulously rendered hundreds of blades of a particular kind of African grass, inviting the viewer to explore the scene as though he were a beetle running up and down the blades. Despite such detailed treatment, the grass retains a three-dimensional quality, full of air and space.

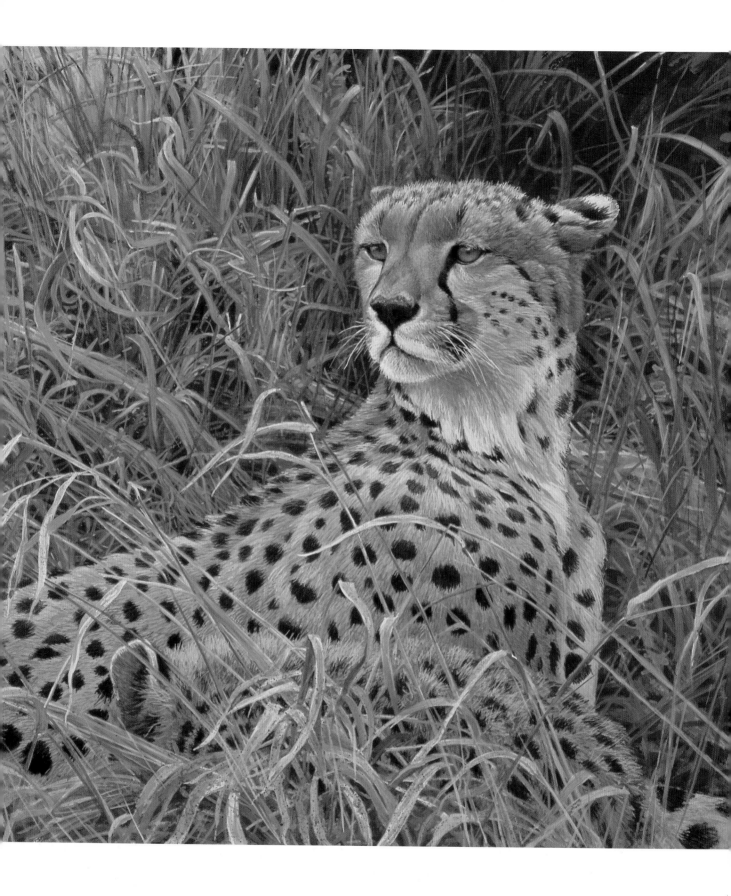

EXPRESSING MOTION WITH DESIGN
Guy Coheleach

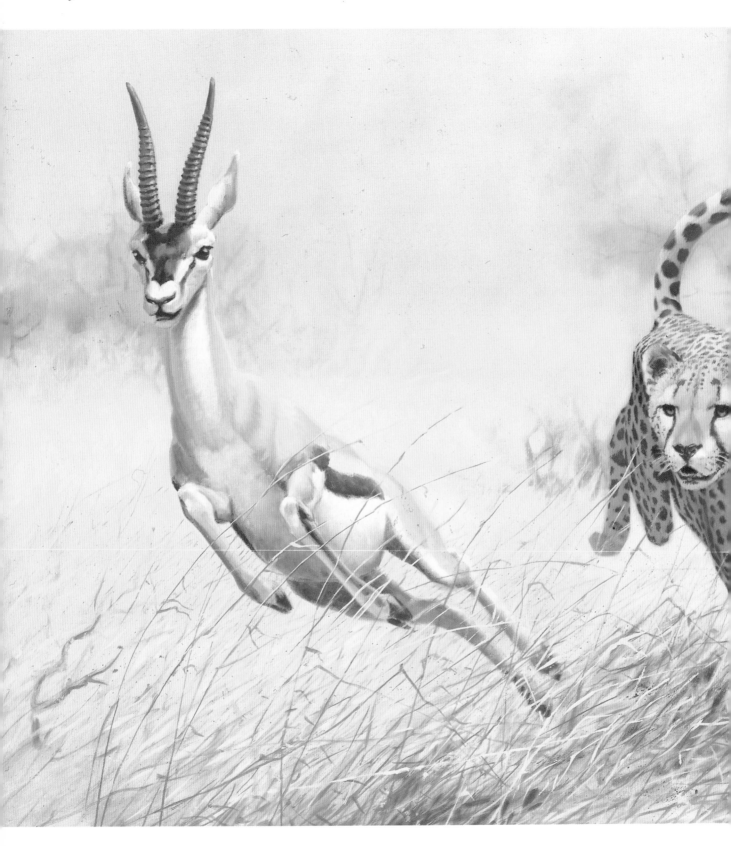

THE CHASE

1967, oil, 30" × 40" (76.2 × 101.6 cm).

Guy Coheleach, who is a hunter as well as a conservationist, believes that his own experiences have been an important factor in conveying the emotions of his paintings. "I know what it's like to chase the prey and I know the terror of being chased," he says. "I don't think you can paint a predator scene effectively until you have been on both ends."

In this drama, witnessed on the Serengheti plains, a cheetah closes in on a Thompson's gazelle. Built for speed, cheetahs are the fastest animals in the world over short distances, running in spurts that exceed seventy miles an hour. The gazelle's only chance for escape lies in its ability to change directions abruptly, but the cat is matching its every turn by using its long tail as a counterbalance, which enables it to save distance with each bound.

Design and action are central to the painting. By juxtaposing the two animals in opposite running positions—the cheetah on the downstroke, landing on its front paws, and the gazelle bounding upward, off its hind legs—the artist is able to convey a greater feeling of motion. Coheleach uses the same technique when painting birds in flight, showing some with their wings up and others on the downstroke.

Working from dark to light, the artist painted the picture rather loosely, doing the cheetah first, then the gazelle, and finally the background. The animals are basically yellow ochre, with warmer areas of raw sienna on the antelope and cadmium orange on the cat. The dark markings and spots were added with burnt umber.

Coheleach painted the dust in the background by dragging a dry bristle brush over a mixture of yellow ochre and cerulean blue, pulling the paint off the weave of the canvas and building it up in the small pits. When the result began to look too grainy, he blended the surface by going back over it a brush loaded with turpentine.

As seen in the diagram for The Chase, *all the foreground lines (formed by grass) point toward the center of the picture's attention—the cheetah, whose primary lines run perpendicular to the foreground direction. The cheetah's lines are repeated in the leaping gazelle, whose color is subdued so that more attention is focused on the cat.*

CAPTURING THE DRAMA OF THE CHASE
Bob Kuhn

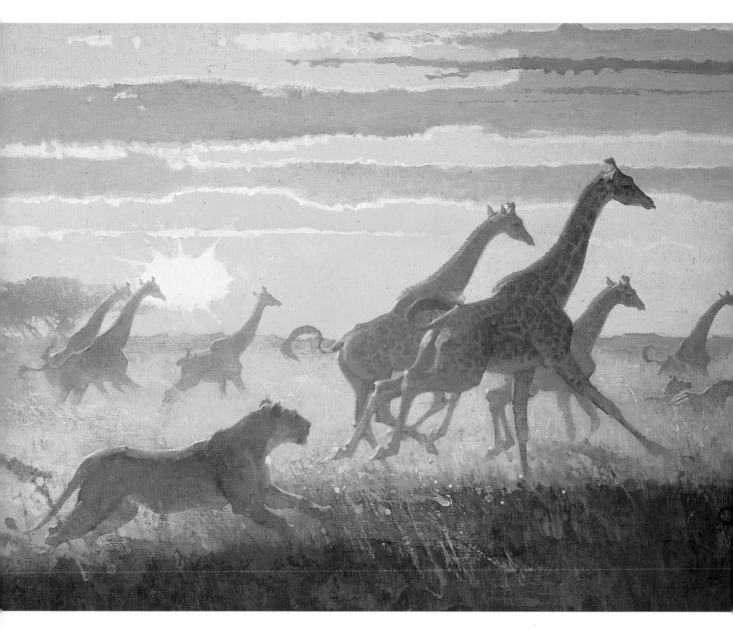

TESTING THE HERD

1975, acrylic, 30" × 40" (76.2 × 101.6 cm).

Bob Kuhn is noted for his paintings of African wildlife. Although he has traveled to most of the world's wild places, he often returns to that continent to observe close-up the vast herds of big game animals and to witness the major drama of the African plain—the timeless confrontation between predator and prey. Here, a single lion rushes a herd of giraffe, although she doesn't have much hope unless a youngster stumbles and the adults leave it to its fate. In minutes the lion will have lost interest, the herd will have galloped on, and the landscape will be serene.

Within the limitations of a two-dimensional surface, the artist manages to capture the flow, dust, and commotion of the chase. Photographs of giraffes in motion verifies their running style, which is uniquely adapted to their strange proportions. A hot palette heightens the sense of excitement and conveys the heat of the African day. Backlighting adds to the drama. The darker tones that shape the animals provide the range of values in the work, and the foreground shadow gives them a base.

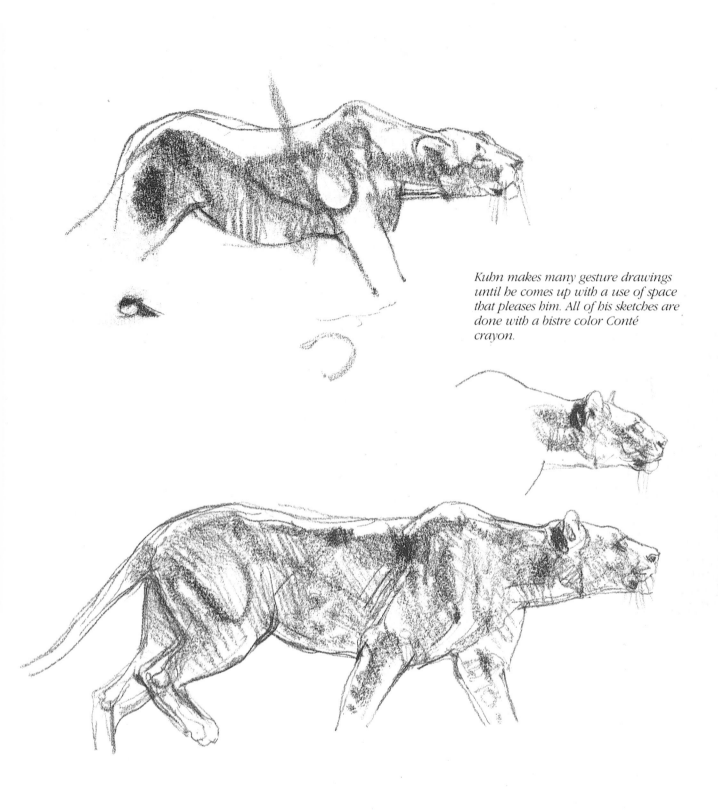

Kuhn makes many gesture drawings until he comes up with a use of space that pleases him. All of his sketches are done with a bistre color Conté crayon.

ADDING BACKGROUND TONES TO IMPLY ACTION
Bob Kuhn

A FLAP OF VULTURES

1974, acrylic, 30" × 60" (76.2 × 152.4 cm).

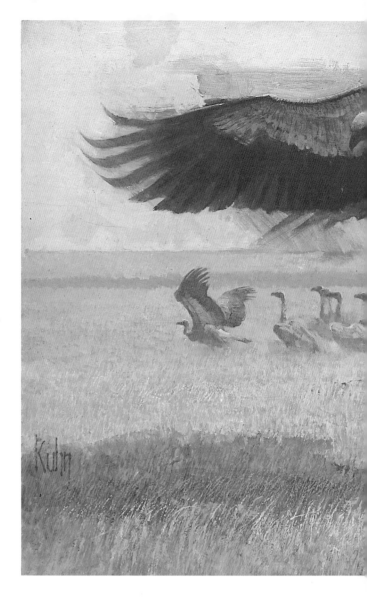

"No painting I have ever done has caused me as much grief as *A Flap of Vultures*," says Bob Kuhn who worked on the piece sporadically for almost five years. The idea sprang from a series of photographs showing hyenas running after feeding vultures, but the artist felt that a lion would make a more interesting, equally plausible, subject.

Kuhn was concerned with achieving an interesting design, but even after all the components were in place, difficulties continued to plague him. The vultures seemed to be suspended in air, with no sense of movement. And the painting fell down toward the right side, needing something to take the viewer's eye back to the top. After much experimentation, the artist finally filled the right-hand panel with vertical abstract shapes, and animated the vultures by adding warm tones behind their wings, giving the impression of blurred action.

The painting had been in several shows, had hung in the artist's home, and had made several trips to the studio without the resolution of a final nagging problem. Kuhn could not make the lion, rearing up to swat a vulture, look believable. One day his wife remarked that it had always reminded her a little of Bert Lahr, as the cowardly lion in the *Wizard of Oz.* "That did it!" says Kuhn. "I brought the painting out to the studio again and performed a sex change operation. The minute I peeled off the mane, the shape began to make sense. I soon had a quite satisfactory lioness, whose cleaner lines were easily understood, and no further mention of Bert Lahr was forthcoming." A recurring consideration for Kuhn is to make a painting look effortless, regardless of the time and struggle required to produce it.

In the end, the artist regards *A Flap of Vultures* as one of his best, holding up well as an abstract design and capturing the true feeling of commotion on the African plains. "It was neither an easy project nor is it a comfortable painting, but it did make me reach a bit and encourages me to sally forth again when a notion seizes me that lies beyond the present perimeter of my confidence."

A quick squiggle of lines can provide the genesis for a Kuhn painting. The artist's primary interest is to capture the true character of the animal.

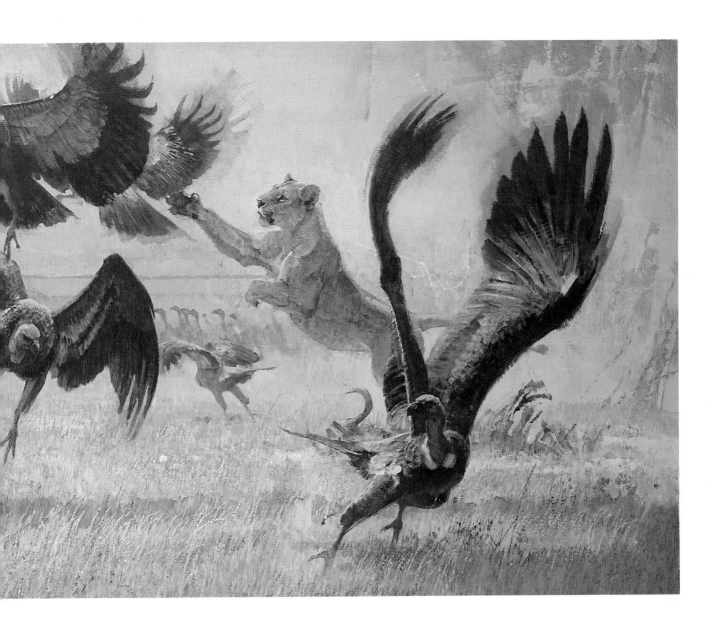

Building Textures with a Palette Knife
Bob Kuhn

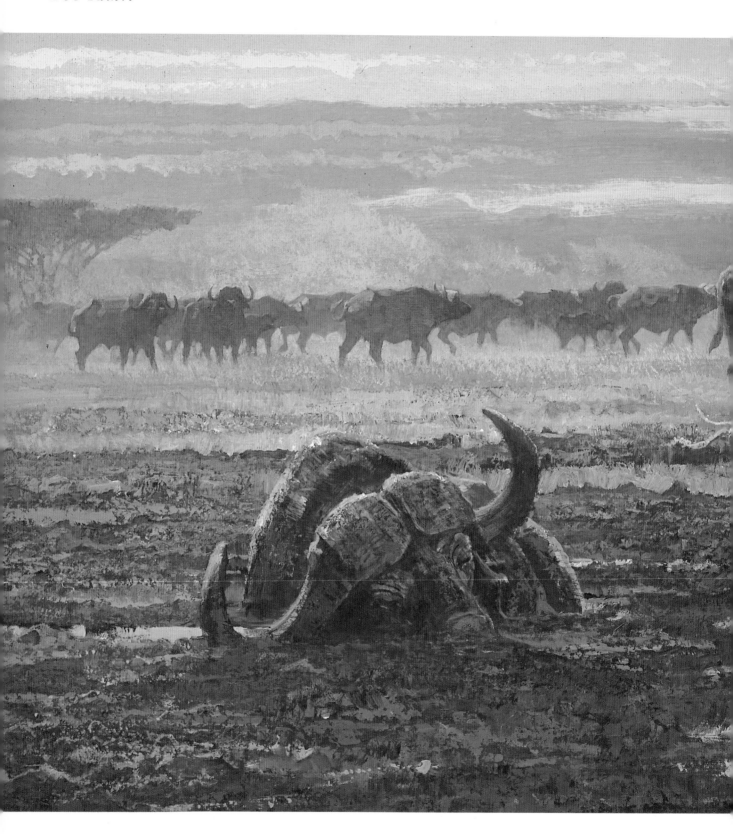

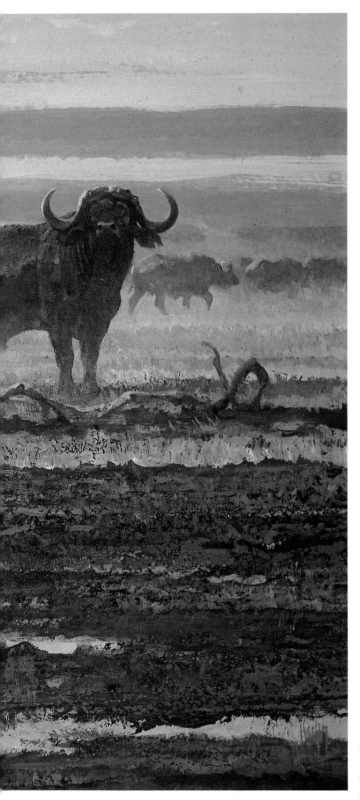

MIRED BULL

1973, acrylic, 24" × 36" (60.9 × 91.4 cm).

Cape buffalo are one of the animals that Bob Kuhn paints best. Though they are really wild cattle, and have many of the same characteristics of their domestic counterparts, they are strong and potentially dangerous animals that can be awesome when wounded or otherwise aroused. Having been charged by buffalo on several occasions, Kuhn is well aware of their murderous potential. Highlighted with mauve, the somber tones of *Mired Bull* convey an aura of menace even though the animal is standing still. The bold application of paint throughout the work is in keeping with its character.

The key to the painting lies in the rich coloration and plastic surface of the foreground. The bog provided Kuhn with an opportunity to make liberal use of his palette knife. The artist builds areas such as this, which are largely abstract, by alternating dark and light until the overall tone, and the shapes within the tone, are satisfactory. "Palette knives create textures that you simply cannot get with a brush, and they serve the additional purpose of keeping me loose," says Kuhn. "I simply put things down and move the paint around until I have the textures that add up to a design, and hope to have the wisdom to stop. If it gets crusty and uneven in the process, so much the better."

The idea for *Mired Bull* came from a film segment that showed a buffalo hopelessly trapped in deep mud. Kuhn recorded the clip with his camera, which he frequently takes with him to movies. The artist has found that, if the action is not too violent, and if he uses a slow shutter speed, he can often get a good image, which provides yet another source of reference for his work. His own file of more than 1500 pictures of buffalo, as well as hundreds of field sketches made over the years, comprised the rest of the background material.

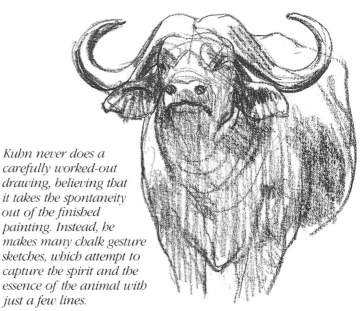

Kuhn never does a carefully worked-out drawing, believing that it takes the spontaneity out of the finished painting. Instead, he makes many chalk gesture sketches, which attempt to capture the spirit and the essence of the animal with just a few lines.

Roger Tory Peterson, *Blue Jays*, 1976, watercolor and acrylic, 22″ × 28″ (55.8 × 71.1 cm).

© Roger Tory Peterson – '76

GARDEN BIRDS

Raymond Ching

Lars Jonsson

Roger Tory Peterson

Capturing the Unique Character of Common Birds
Roger Tory Peterson

Robin

1978, watercolor, acrylic, and gouache, 19" × 16½" (48.2 × 41.9 cm).

The idea for *Robin* originated from its potential use as a porcelain plate, and therefore the composition had to fit a circular shape. Originally, Roger Tory Peterson painted it on white Whatman board, but when the plate project was temporarily abandoned and it became a limited edition print, he airbrushed in an even gray tone behind the bird. The open background depends on the composition to carry the subject, which is rendered in the Audubonesque tradition.

Each bird is different, and Peterson looks for the basic stance or "gestalt" of a species. Although the robin is an extremely well-known bird, its character is difficult to convey. Here, the artist wanted to capture its sturdy good looks in full spring finery before it had raised its first brood of young. The work was built up with a series of thin, transparent washes, in the traditional English watercolor method. Peterson laid in the darks first, letting the white paper carry the lights. Finishing touches were applied in gouache and acrylics, to give some modeling to the form. The dogwood blossoms were rendered from fresh material growing just outside the artist's studio. Peterson uses flat one-half-inch or three-quarter-inch sable brushes for laying in washes, and sables as fine as a number 1 for details.

© Roger Tory Peterson — '78

MOCKINGBIRD

1978, watercolor and acrylic, 21" × 17" (53.3 × 43.1 cm).

The format for *Mockingbird* also was established by the necessity of adapting it to a porcelain plate. The painting was done on a white board originally—the background tone was dubbed in by the engraver for the print. The bird is shown in its wing-flashing pose, an action seen especially when it is searching for insects on the ground, although the exact function is not known. Peterson tries for value first, beginning a painting by laying out the elements in a general way, and not finishing any one thing before going on to another. In the case of the mockingbird, which has relatively little color, he simply laid in the pattern. Adding shadows to the whites, while keeping them in balance with the rest of the painting, was rather tricky to handle, and Peterson modeled the bird slowly, building it up with darker transparent glazes. For final shaping, he then worked the highlights over the darks, in a process called scumbling. The artist felt that portraying a mockingbird on a magnolia would be a cliché and so chose to show it with a spray of the large exotic rose that grows wild in the sandy soil up and down the eastern coast.

Peterson often roughs out half a dozen or more compositions of the same subject and then carries through the one that seems to be going best. To verify accuracy, he will view the work upside down or through a mirror, for a fresh perspective. The artist uses his own photographs as a memory jog, as well as museum skins specimens for details such as the structure of bills and feet. "Field experience is the most important thing of all," says Peterson. "Simply having a clipping file does not work because your paintings will become derivative. Only by studying the subject in the field can one arrive at an original concept."

ACHIEVING LUMINOUS, VIBRANT REDS
Roger Tory Peterson

SCARLET TANAGER

1977, watercolor and acrylic, 22" × 18" (55.8 × 45.7 cm).

"As an artist I find the vivid red of the scarlet tanager very difficult to simulate with pigment," says Roger Tory Peterson, who feels that no watercolor, used pure, can capture the bird's brilliant fluorescence. To solve the problem he lays down a wash of transparent cadmium yellow, and then works it over with thin washes of vermilion, allowing the warmth of the yellow to glow through. "Not so much yellow that it becomes orange, just enough to give light to the red," advises the artist.

Not all red birds receive the same treatment, however, depending on the source and quality of the light. Although its face and breast can be as intense as a tanager's in bright sun, a cardinal's plumage is generally duller—the feathers on its back and tail are actually edged with gray. When painting it, Peterson does not start with yellow but rather washes flame crimson or vermilion directly over the white paper, which results in a cooler, less vibrant red.

Peterson sketched this scarlet tanager directly onto Whatman board, then built up its colors with a series of four or five clear glazes, allowing each to thoroughly dry before proceeding with the next. He finished by adding a touch of opaque gouache here and there for modeling. Since tanagers are phlegmatic birds, which tend to move slowly through the upper tree canopy, the artist was careful not to show it in an unnaturally flamboyant position. The quiet composition is a classical one, with the subject placed off center and facing inward. The painting was inspired by a pair of tanagers that like to perch in a huge tulip tree on the artist's property in Connecticut.

"Flowers always look best when done entirely in transparent watercolor, with no acrylic touches," advises Roger Tory Peterson, who painted the tulip tree blossoms in thin washes of yellow ochre and yellow green, from fresh material.

© Roger Tory Peterson — 77

EMPHASIZING COLOR WITH TONED PAPER

Lars Jonsson

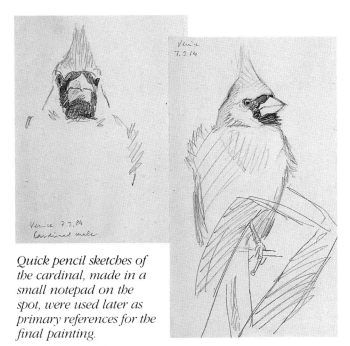

Quick pencil sketches of the cardinal, made in a small notepad on the spot, were used later as primary references for the final painting.

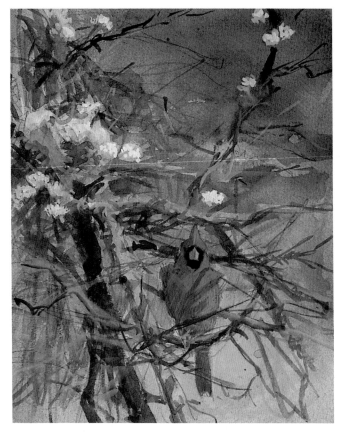

A small colored sketch on gray-toned paper enabled the artist to determine the balance of colors and to see if the overall concept worked.

SIGNALS OF SPRING

1984, watercolor and gouache, 19½" × 16" (50 × 40 cm).

Gouache on toned paper can capture the brilliant hues of some birds more effectively than transparent watercolors on white paper. Lars Jonsson used gray Canson paper for this portrait, one of the few colored papers that can be used for the watercolor medium. "The male cardinal is such a striking American bird," says the Swedish artist. "Its brilliant red plumage and raised crest are a clear signal to other males to stay away, while attracting the females. I wanted to emphasize the power of this message, and the self-confidence I thought I saw in the bird, by having him look the viewer straight in the eye. Also, the subject has been painted so many times that I felt a head-on approach would be different."

Jonsson saw the bird in Louisiana, during a visit to the Oakley House in Saint Francisville, where Audubon once stayed as a tutor for several years. The cardinal was perched in an old cherry tree, and the artist was attracted by the simplicity of the colors—red, white, and gray. He sketched the bird on the spot and took photographs of the tree, then completed the painting back in his studio in Sweden.

To start, Jonsson did a small colored sketch on a swatch of the same toned paper, and then made a pencil drawing of the final layout. He began the painting by laying in the background in a rather bright, yellow ochre watercolor wash, which he then gradually toned down with several layers of dirty bluish- and brownish-gray gouache. Working everywhere at once, the artist quickly covered the paper with some of all of the colors, to get a sense of how the picture would work as a whole. The cardinal's body was painted primarily in gouache, with a mixture of scarlet lake, cadmium red, and cadmium yellow deep. The major difficulty lay in how to indicate shadows and highlights without dulling the bright red plumage. The faint stripes on its belly, sometimes seen when a bird's plumage is fluffed up, indicate where the feathers are attached to the skin in rows. Jonsson took advantage of this anatomical effect to emphasize the roundness of the body. Normally, a bird's form is modelled with blues and blacks for the shaded areas, and colors mixed with white for the highlights. Here, Jonsson used the scarlet and some of the yellow wherever he could for the lighter parts, although some white was added on the cardinal's forecrown and the side of its breast, where the sun is reflected. Washes of deep, cold grenadine gouache were used for the shadows, together with some lilac.

Developing the structure of the tree limbs proved difficult. Jonsson worked from the pictures that he had taken and from actual branches removed from a cherry tree in his garden. The lichen was painted in a cool greenish-gray, mixed from different colors to give it more life. Additional yellow in the highlights was added where the sun struck it. At a late stage in the painting, Jonsson felt that the profusion of lichen-covered branches distracted from the bird, and so took many of them down to pale shapes again, realizing that otherwise details would dominate the painting.

He saved the white flowers for last. "I knew they would lift the painting up," he says. "It was like waiting to open a Christmas package." The areas of white serve to balance the red intensity of the bird.

BLENDING TINTS TO CONVEY BRIGHT BLUE
Lars Jonsson

BLUE GROSBEAK

1984, watercolor and gouache, 16" × 14" (40 × 36 cm).

To capture the vibrant colors of this blue grosbeak, Lars Jonsson painted the bird on a gray-toned background, which tends to make bright colors pop. The grosbeak's blue is actually a mixture of several colors: ultramarine and cerulean blue, violet, and some green. Modeling its body presented problems, since the addition of lighter tones would tend to diminish some of the brilliance of the blue. Jonsson handled this by overpainting various tints of mixed colors, with very fine strokes, beginning with a combination of opaque white and ultramarine blue, then greenish blue and white, followed by pale violet and white. The viewer's eye blends the colors, and the brightness of the original blue is retained.

Jonsson made many sketches of the grosbeak before he was satisfied with its posture. He wanted its head turned forward and the right wing to slightly overlap the left, so as to emphasize the fine edges of the flight feathers. The small shadow thus created also helped to add light and build the form of the bird. To paint its wings, Jonsson covered the middle of the feathers with a bluish-gray wash, darkened the central vanes, and tinted a pale brown on the outer edges. Then he built up all the colors with more tints. The rusty brown on the grosbeak's wing bars and back was applied in a series of washes made up of Winsor red and yellow ochre, blended with yellow ochre gouache. Some lilac and alizarin crimson were added where the bend of the wing goes into shadow.

Jonsson made several pencil sketches of the weedy field before he was satisfied with the pattern. "It was a matter of playing with it, working back and forth," he explains. "Very often when I do that a line, a color, or a feeling of perspective appears by chance, which adds something nice that I keep and strengthen." Initially, the artist felt that he worked the vegetation in too much detail, and had to knock it back when he saw that it was competing with the main subject. The flowers were added last, in bright yellow gouache.

When a blue grosbeak suddenly jumped up on a stem in a Texas pasture, Lars Jonsson was startled by its brilliant color and decided to do a painting. He sketched the bird both in pencil and watercolor in the field, then finished the work in his studio in Sweden.

SKETCHING SONGBIRDS IN THE FIELD
Lars Jonsson

WARBLERS

Watercolor studies, 8½" × 5½" (21.6 × 13.9 cm).

"Sketching songbirds is one of the most difficult things you can do," says Lars Jonsson. The key is to get a direct line going from your eyes to your hand. Don't think about what you're doing, just *do* it." The artist spends most of his time outdoors, drawing and painting birds, and feels that when he is sketching he is constantly learning and developing his ability to see. He believes that working directly from the living subject is the best way to understand it and to reach the intimacy that he feels is necessary to capture the essence of a species.

On a recent journey from Florida to Alaska, the Swedish artist made many studies of American wood warblers, following each with binoculars as he made quick pencil sketches and then adding a wash of color, to capture its correct hues. For Jonsson field sketching is a habit, a constant training, and a way to experience nature. Later, some will be useful as references for full paintings, but the value lies just as much in the act of sketching itself.

Jonsson stresses the importance of approaching a subject free from preconceptions which, he acknowledges, is harder to accomplish than it might appear. Often people don't draw what they see but rather what they remember from a guide book, or a mistaken idea of what the bird "ought" to look like. "Because birds are always in motion, it is easier to get a picture from inside your head," he says. "But if you don't do the actual field work, you won't be able to establish a personal connection with nature and your possibility of developing as a wildlife artist will be limited." Jonsson feels that it is often more valuable to do many rough or unfinished sketches than to work the same one over and over, erasing the errors. He reminds his students that a watercolor field study is just a piece of paper after all, a useful tool with which to experiment and develop. "Never hesitate to take risks," he advises. "Being out there in nature, experiencing it—*that's* what it's all about."

Hooded Warbler

Red-faced Warbler

Painted Redstart

Kentucky Warbler

Magnolia Warbler

Black and White Warbler

SEEING BEAUTY IN THE COMMONPLACE
Raymond Ching

This study of a starling's head, made from a fresh study skin, later became a reference for a painting. Ching was fascinated by the elegant white spots on its otherwise drab plumage.

HOUSE SPARROW: ADULT MALE

1976, oil, 20⅞" × 15" (53 × 38.1 cm).

Raymond Ching prefers to ignore red cardinals and peacocks in favor of such familiar birds as sparrows and starlings, returning to the same subjects again and again. From years of close observation, he has gained an intimate knowledge of these garden birds and likes the discipline of capturing their spirit in a way that is both accurate and an expression of his own vision.

Here, a single male house sparrow, perched on a piece of string, is drawn life-size, on a plain background. "I wanted the interest in this painting to be gained entirely from the commonplace," says Ching. "The modest size of the painting is no accident, and the absence of any decorative or highly colored background is entirely to my purpose." The artist sized the untempered Masonite panel with four or five coats of gesso, using a two-inch house painting brush, and sanding it down between each coat. He applied the final gesso layer with a much smaller oil painting brush, working quickly, with small strokes in all directions. He then added several thin washes of neutral color, rubbing each off again with a rag. The remaining film of paint picks out the brushstrokes and provides an interesting background texture.

The bird was painted from a study skin. The essence of this particular sparrow is so clearly conveyed that the viewer can almost feel the warmth and softness of its body. It is relaxed and sits somewhat lopsided, yet remains perfectly balanced, its small weight measured by the slight downward pressure on the string. Its wings seem like separate structures, yet their point of attachment is so sure that one knows the sparrow could fly off in an instant.

Ching uses only the small range of seven or eight colors that have a permanent AA rating, and has difficulty reconstructing how he arrived at any one color. He simply squirts all the hues in that range out on his palette at the start of every painting and proceeds through trial and error. "I don't think it particularly matters what colors you use, or what brush," says the artist. "What matters is that you've really got to want to do it. When I'm painting that little sparrow, I want to do it more than I can bear."

DRAWING FINE DETAIL WITH PAINT
Raymond Ching

Ching does not use binoculars and almost never draws a bird in the field, preferring to let it take shape in his mind. These pencil sketches of wrens were pre-studies for wren paintings.

Ching worked very carefully on either side of each strand, leaving a thin, unpainted line where the paper showed through. Where he accidentally obliterated a strand, he then went back and put it in with white paint.

WINTER WRENS

1972, watercolor, 28" × 21" (71 × 53.3 cm).

An extraordinary draftsman, Raymond Ching has absolute control over the finest details of a drawing. When preparing for a watercolor, he makes an elaborate pencil study, containing all the values, which looks very much like a black and white photograph. Consistently, the artist does not experiment with nature; rather, he draws what he sees, exactly, without further development.

After the drawing has been transferred to the final surface, usually by tracing, Ching will start the painting at any one point of interest and work methodically down the surface until he gets to the bottom. Color is of secondary interest to the artist. "If I started making decisions with the paint, I'd lose control of the painting," he says. "The more paint I add the more out of control I get, so that I want all the really serious work done long before the paint goes on."

Ching does not work with pre-mixed puddles of color. Instead, with every brushstroke he makes, he mixes the color all over again, his hand moving back and forth between palette and painting surface so rapidly that he wears out brushes every few days.

The cobweb studies for *Winter Wren*, along with the other details of the window, were made at an abandoned shed on the artist's property in England, in freezing winter conditions, and then taken back to the studio, where they were carefully fitted into place in the highly detailed pencil "map" of the work, and appear in the final painting almost exactly. The old tobacco tin of rusting, forgotten bits of chain, nails, and seed packets was set up in the studio like a still life and drawn to fit. The two adult winter wrens were rendered from study skins in the artist's collection. All the elements, including the birds, were painted life-size.

Although he usually prefers to draw details, Ching chose to paint the cobweb studies because the fragile strands were visible only in relationship to the darker background, and so lent themselves to white, rather than pencil lines. Ching painted the background transparently, from dark through to light, allowing the white paper to show through for the cobwebs themselves. "It works best if you get it right the first time, so it means you've really got to think about what you're doing," says Ching. "You've got to worry and you've got to have very considerable control over your hand. It's the trying to get it done right the first time that offers the painting its underlying excitement. For me, it's the worrying that does it."

Even with such exacting detail, Ching seldom uses anything finer than a number 6 brush. Larger brushes can have as fine a point as smaller ones, he explains, but because there is more body to the brush he has more control over the paint. "My advice to any artist is to take at least two or three brush sizes bigger than you need." Ching works only on 100 percent rag paper, stretched tight to give it surface tension.

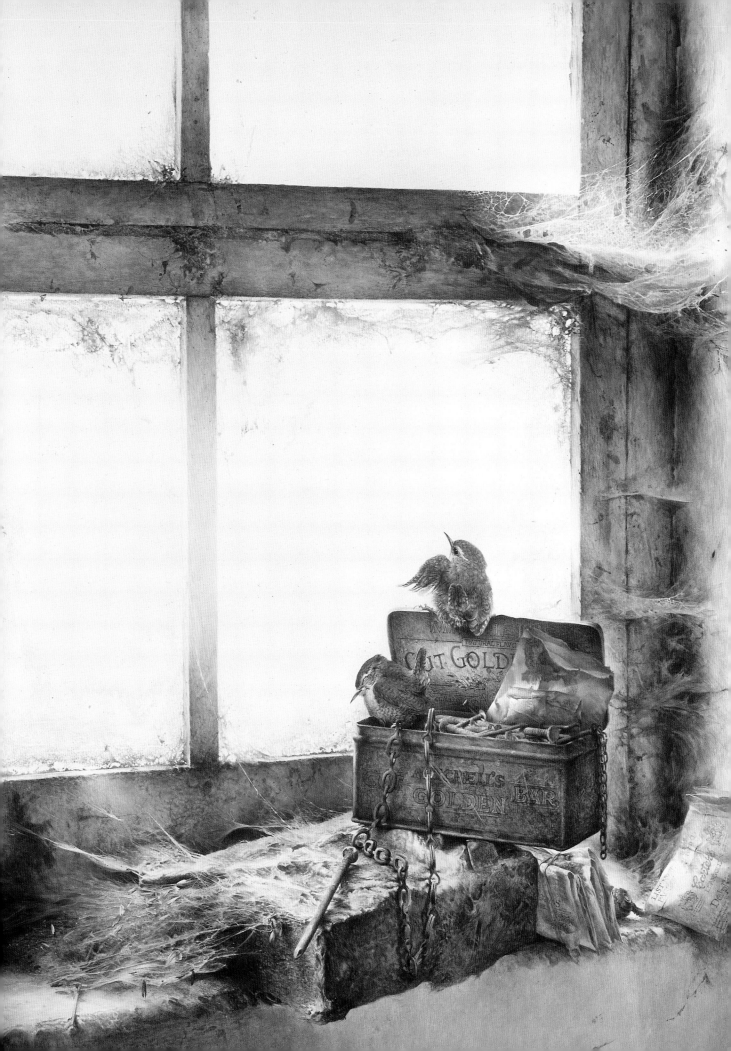

WORKING WITH THE LIMITATIONS OF A MEDIUM
Raymond Ching

SWALLOW

1975, acrylic, 28" × 22" (71 × 53.3 cm).

While on a walk near his studio in Sussex, England, Raymond Ching noticed some swallows flying in and out of an abandoned barn. For the artist, it was the black hole of the missing windowpane, as much as anything, that turned the scene into a potential painting. Ching worked from an old window frame in the studio, kept because of its faded, chipped white paint and dusty, cobwebby quality. He added the drain pipe and stone sill, and drew in the swallow, life-size, from a studio study skin.

Ching decided to paint the work in acrylic to take advantage of a difficulty he has had with that medium. He explains, "I noticed that the way the light was hitting the window gave the glass a dirty, milky effect, and I thought back to the first time I saw that effect—when the acrylics weren't going very well. I had intended to paint the scene in watercolor, but I decided then to paint it in acrylics for that reason alone." By scumbling acrylic on top of other acrylic paint, laying paler washes over darker ones, the artist got the effect he was after.

Ching acknowledges that there is no one surface or paint that is absolutely right. Because Ching finds that he makes his paintings as the result of a struggle against the *limitations* of a paint, he abandoned acrylics after a few attempts, deciding that their ease of handling was for him, ultimately, their failing. Acrylics dry quickly, unlike oils, and can be overpainted, unlike watercolors, where an artist must get everything right the first time. "If you don't have to face up to a problem," says Ching, "I believe that you lose the nervousness of the painting—its underlying energy force. The swallow at the window is not really there and this is not really a window. The illusion is purely a consequence of my having done battle with a blank piece of paper and the paint that I chose."

Ching obtains details, such as size, color and pattern, from study skins, but establishes the form and character of a subject from observation of the living bird.

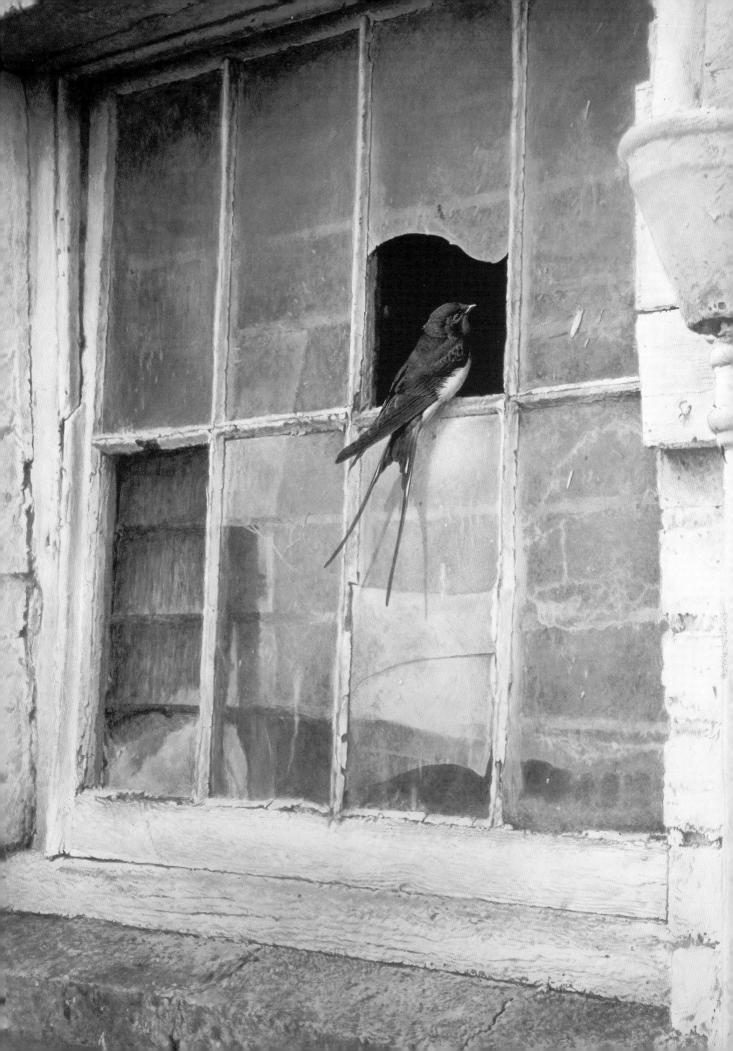

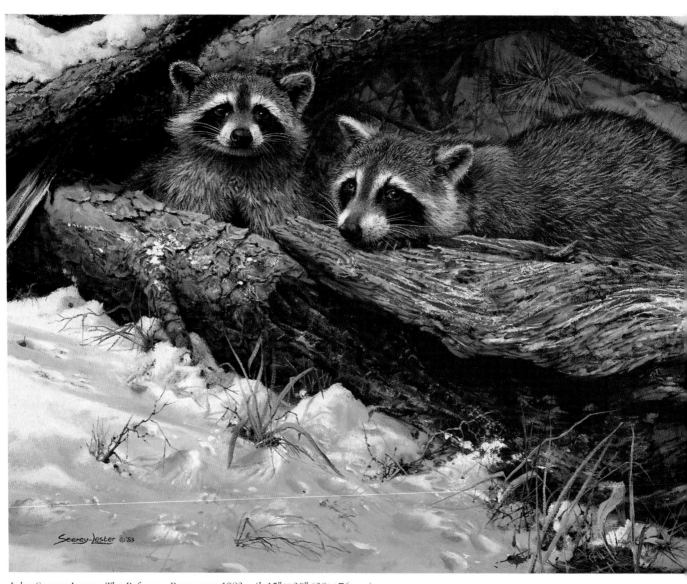

John Seerey-Lester, *The Refuge—Raccoons*, 1983, oil, 15″ × 30″ (38 × 76 cm)

THE WORLD OF
SMALL ANIMALS

Robert Bateman

Thomas Quinn

John Seerey-Lester

CREATING VISUAL TENSION WITH LIGHTS AND DARKS
Robert Bateman

ON THE ALERT—CHIPMUNK

1980, acrylic, 8" × 13" (20.3 × 33 cm).

Bright and quick, a chipmunk is caught mid-stride as it explores a snowy ledge for food. In another second it will have disappeared, with a scolding chirp, between the rocks or beneath the ferns, into one of several dark holes that the artist, Robert Bateman, has provided. Although he has painted the chipmunk in reasonable detail, the artist avoids a static composition by placing the animal off-center, underscoring its sense of motion. The contrast between the dark, vertical planes of the background and the light, flat surfaces in the foreground enhances the visual tension.

Bateman is a naturalist as well as an artist. This painting captures the chipmunk's small world with accurate realism, from the structure of the granite rocks to the polypody ferns and red-capped British soldier lichens. Although the artist is careful to show how the animal fits into its environment, he also makes use of elements in the landscape to reinforce the dynamic rhythms of the painting. Here, the ferns echo the shape of the chipmunk's tail.

All of Bateman's work is based on years of observation in the field. He learned to draw with the "gesture" method taught by Kimon Nicolaides who for many years was a master teacher at the Art Students' League of New York. Nicolaides encouraged his pupils to make very rapid impressions of subjects, responding to the sense of motion rather than mechanical detail. He advised, "In order to draw you must first make 2000 mistakes." Bateman has more than 10,000 sketches in his files, representing forty years of first-hand study. "I can capture an image of something I've seen for only two seconds," Bateman says. "I may then work on it for a few minutes, while it's still fresh in my memory, using my knowledge of animals—their proportions and anatomy—to help me finish it off."

Bateman sketches quickly, correcting errors and changing a pose as he goes along, without tissue overlays.

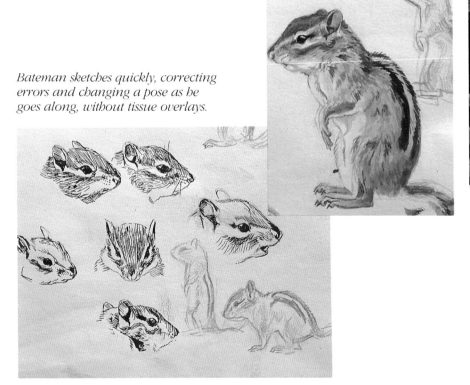

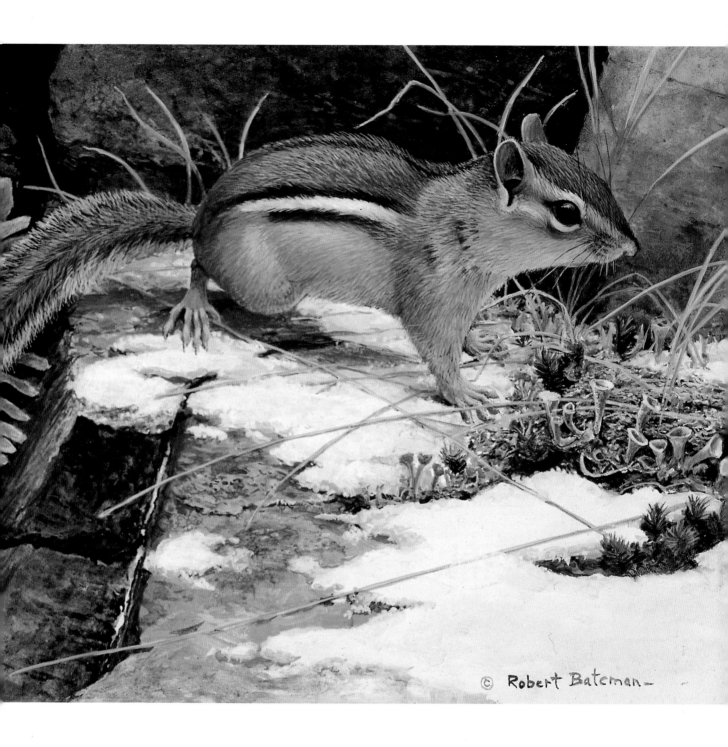

© Robert Bateman

BLENDING SUBJECT AND BACKGROUND
Robert Bateman

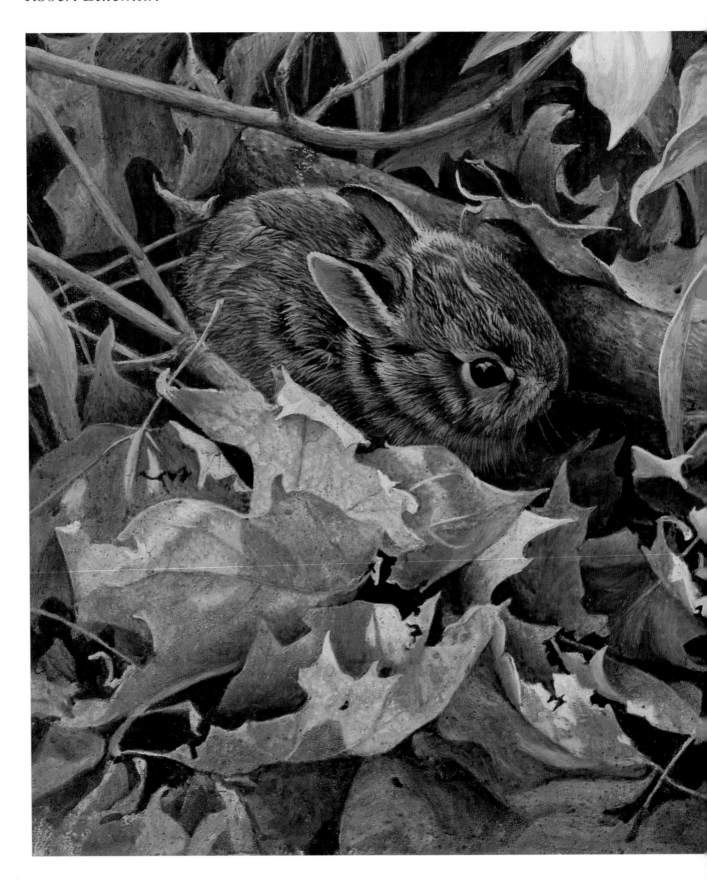

AMONG THE LEAVES—COTTONTAIL

1977, acrylic, 13" × 18" (33 × 45.7 cm).

"When I go for a walk, my eyes are usually looking down at the ground five or ten feet ahead of me," says Robert Bateman, who prefers to move through a landscape slowly, examining nature by the square yard. *Among the Leaves— Cottontail* was painted from that perspective, as though the viewer has been exploring a hardwood forest in early spring and suddenly comes upon a motionless young rabbit, almost underfoot. Instinctively, the frightened animal tries to be as inconspicuous as possible, but its bright eye reveals its tension. Any closer, and it will break out of its "freeze" and flee.

Bateman worked out the bold forms of the rabbit first, blocking out concave and convex areas to show form and shape. He then refined it, adding details by working back and forth from light to dark and dark to light. The rabbit's whitish hairs were laid down with a slightly warmer wash. The artist helped the illusion of camouflage by washing several thin layers of burnt umber and Payne's gray over the small creature to push it down and blend it into the background. To further draw the eye away from the cottontail, Bateman emphasizes the leaves, which he has rendered in full detail. "I would like to put in a good word for dead leaves," says the artist. "Most people consider them a nuisance, but if you look at one from an abstract point of view, its structure is quite complex."

The wildflowers also serve to distract the eye, and add color to the otherwise brown scene. Trillium, the official emblem of Ontario, Canada, where the artist lives, bloom in early May, before the trees come into leaf and shade the forest floor. To avoid the cliché of "prettiness," the artist cut the flowers off at the top, the effect reminding him of a painting by Degas, in which a rack of ladies' hats goes up at an angle and out of the picture.

USING A GRADATED BACKGROUND TO SUGGEST SPACE
Thomas Quinn

Thomas Quinn
1982

RUNNING COTTONTAIL

1982, acrylic and gouache, 33" × 23" (83.8 × 58.4 cm).

When a patron requested a large work concerning a jack rabbit, California artist Thomas Quinn felt somewhat hesitant about the undertaking. He decided to investigate "rabbitness" first, experimenting with the smaller cottontail. Both species share the rabbit characteristics of large eyes, mobile ears, and subtle tonal changes in the coat, as well as speed and the ability to turn abruptly within their own body length.

"I painted a few examples of a cottontail in repose, some stretching, some sniffing," Quinn says. "I was about to have my most ambitious variation, of a cottontail climbing a large bush lupine to feed on the blossoms, when the thought occurred to simply paint one accelerating, perhaps instantly airborne, above its shadow, snapping through a few long grasses." The result is *Running Cottontail*.

Quinn began the painting by laying down a series of transparent washes on a gessoed panel. He mixed raw sienna, burnt sienna, raw umber, yellow ochre, yellow primrose, and mars black in solution with a great deal of water. By scrubbing various amounts of the colors together in a flooded enamel butcher's tray, he came up with a color that seemed to represent the sunny warmth of oat hay. The artist then started at the top of a steeply inclined board, rhythmically brushing clear water onto the surface and gradually introducing the acrylic solution, wet-into-wet. Gravity assisted in gradating the wash from light at the top to progressively darker at the bottom. When the surface was completely dry, another wash, and then another, was applied until half a dozen transparent layers were fast to the gesso. Quinn had already worked up a master drawing of the cottontail. Now he had to decide whether it should travel from left to right or from right to left, merge or emerge from the background. The artist finally turned the board 180 degrees, so that the darkest area was at the top, which allowed the rabbit to come forward out of the darker background into an area gradated to light.

Quinn then cut a piece of white bond tape into a half-inch square and darkened half of it with a black marker. The black next to white represented the ultimate contrast on the neutral background. He moved the bit of tape around until he found a comfortable and purely abstract spot. This was where the maximum contrast would occur at the center of focus—the head of the rabbit.

The design called for action, and the artist relied on the device of diagonal positioning, which included a lot of negative space to the right, where the rabbit had been just a second before. The effect was reinforced by the use of converging lines, as seen in the long stems of the grasses and the cast shadow. For positional emphasis, the cottontail's ears and brow were painted in higher contrast than its hindquarters, and a single note of pink was added in the near ear.

UNIFYING A PAINTING WITH SIMPLE VISUAL EFFECTS
Thomas Quinn

BADGER

1983, acrylic and gouache, 10" × 21" (25.4 × 53.3 cm).

Thomas Quinn's impulse to paint a badger was sparked by the memory of a dramatic encounter with this uncommon species, while training dogs with a friend. "We were in conversation, mid-sentence in fact, when I felt a presence at the edge of my vision," the artist recounts. "About fifteen feet to my right there was something that wasn't there a second before, and we found ourselves silently regarding a totem-still badger. Then another burly form rose out of the sand, like a small freight elevator pushing up through a city sidewalk. We were bracketed by a second badger, thirty feet away. A minute or so elapsed and then, as if by electronic cue, both broad-shouldered, long-clawed, striped-nose creatures lowered simultaneously into the ground and we were alone."

This vision was before him as Quinn prepared to paint. He had made several small thumbnails in pencil, and then in black marker, and had concluded that this first attempt should deal with the business end of the badger—the forward half with its immense shoulders, huge digging claws, and shovel-like head, but most of all, its gradated markings. Quinn began by laying in a transparent wash of mixed acrylic on a gessoed surface, then lightly penciled the badger in the area predesignated in the thumbnail sketch. More acrylic washes were added to imply the initial form of the animal and to seal the graphite to the surface. While this dried, Quinn switched to gouache and indicated the minor rockslide of the badger's dig. If he hadn't liked the results at this point, he could have removed the gouache without lifting the tough acrylic underpainting.

Quinn next turned to building the badger with his brush, alternating acrylic with gouache. He mixed his darks from ultramarine blue and burnt umber, reserving the maximum true black for later emphasis. A dark partial ellipse anchored the badger's back and suggested the burrow. More darks weighted the animal's head and mask, and a shot of ivory black gouache brightened its near eye.

The artist added the strong contrast in the work by knocking in a hot lick for the nose stripe with opaque white acrylic, for a focal accent. "The work was simple, with a somewhat silvery look but still in need of a graphic vitamin," says Quinn. "I added an area of full saturation blue in the lower left corner that provided visual tension, and suggested the surface of water as well as some implied elevation and perspective." The speed and looseness of certain brushstrokes unified and characterized the heavyset animal and suggested some of its intensity and busyness.

RACCOON WITH TROUT

1979, acrylic and gouache, 26" × 30" (66 × 76.2 cm).

Raccoon with Trout derives its impact from a timeless and sophisticated compositional theme—a circle in a square. Quinn intended a dynamic, revolving circle, with the raccoon's rounded back forming the upper half and the bent trout providing the lower curve. Its spots repeat the circular theme. The artist had worked out the painting the same way as that of the badger. Although he felt that he had a good warm/cool graded background, a decent coon, and an acceptable trout, something important seemed to be missing.

A week passed, with the work off the drawing board when the answer came to Quinn in the early morning hours. After breakfast, he readdressed the painting and added a suggestion of water and reflections, made out of the same pigments and colors as the background washes. This neutral filler, or "visual glue," combined the elements and the work became whole.

Before starting to paint, Quinn made several drawings of the raccoon, employing the formal, abstract design of a circle within a square.

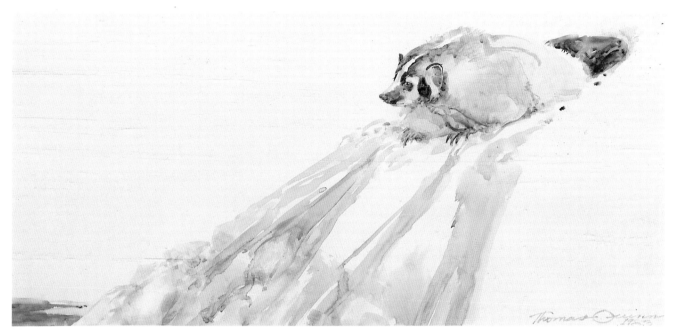

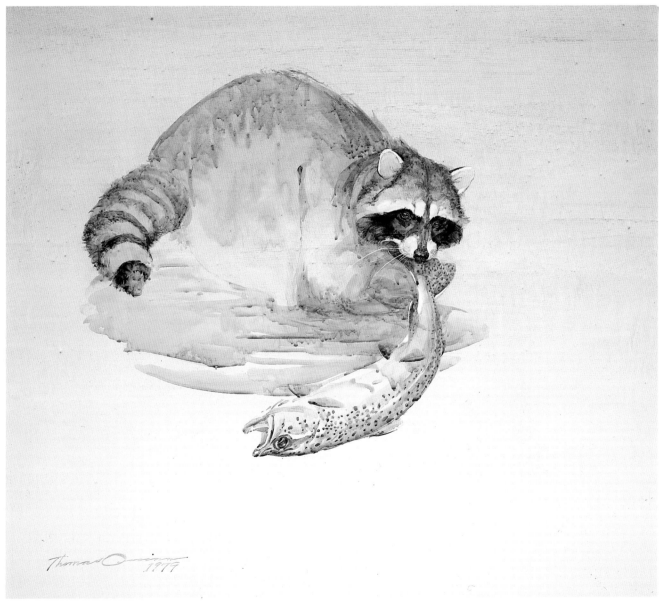

DESIGNING WITH OVERLAYS
Thomas Quinn

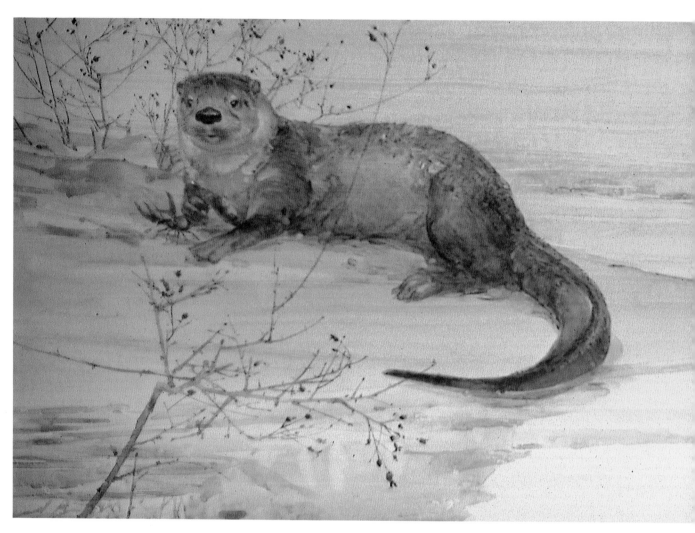

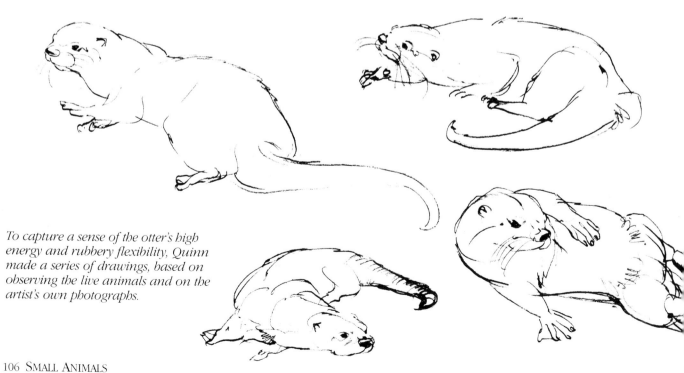

To capture a sense of the otter's high energy and rubbery flexibility, Quinn made a series of drawings, based on observing the live animals and on the artist's own photographs.

AMERICAN RIVER OTTER AND WILD ROSE

1984, acrylic and gouache, 21½" × 41" (54.6 × 104 cm).

Otters occasionally show up in a creek a short distance from Thomas Quinn's California studio. He also has seen the playful, yard-long animals in a nearby marsh where, along with tules and rushes, there is an abundance of wild rose. When the artist finally decided to approach the subject in a painting, he visited a local scientist to photograph her captive specimens. "I quickly learned that there is no optimum moment to record a river otter," says Quinn. "You simply burn up a lot of film and hope to arrest the constant motion." He tried to edit his results toward the shapes that he felt best typified the animal but found no single frame satisfactory. Only by combining half-a-dozen attitudes could he begin to grasp the otter's extraordinary mobility.

Quinn primed a panel with gesso and began the work by covering it with a wash of acrylic paint gradated downward from warm to cool and, at the same time, changing from medium value to light. This was accomplished by washing seven or eight thin layers of mixed raw umber, burnt umber, ultramarine blue, and mars black, allowing a complete drying time after each layer. The tough, waterproof base provided an overall middle value which Quinn could then paint against by adding darker or lighter tones. Also, due to the neutrality of the wash color, he was left with an entire range of intense colors from which to choose, should he need them.

The second major technical decision was to carefully plot the curve of the large horizontal sandbar, which Quinn planned as a foil for the tail curve of the otter. The shape was derived from an overlay drawing done in gray marker on tissue, which the artist moved around the panel until he found the right placement. Laid down with a combination of raw umber, ultramarine blue, and a dash of raw sienna, and neutralized with mars black, the sandbar was graded from light at the beach edge to slightly darker as the land element gained more elevation.

Using a similar tissue, and paying attention to mass and silhouette, Quinn then positioned, and lightly penciled in, the otter. Broad washes of acrylic, consisting of raw sienna, raw umber, burnt sienna, cerulean blue, and some burnt umber, were applied to the drawing to seal the graphite and to begin to determine the limb intersections, surface planes, and other structures, such as feet and tail. The artist made a strong effort to use the cool reflected light of the sky on the top plane and warmer hues on planes reflecting light from the ground. Once the value was generally correct, the paler areas on the otter's face were added with permanent white gouache. In turn, parts of the body were glazed and adjusted with more acrylics to further set the animal's overall tonality.

When two-thirds of the otter had been roughed out, Quinn added the calligraphic spray of twigs and rose hips behind it in ultramarine and burnt sienna gouache, using a number 12 sable brush. The opaque red notes are done in alizarin rose madder and cadmium orange gouache, the transparent ones in cadmium red light and burgundy lake.

For an unusual touch of coppery-green, Quinn chose a species of local crayfish as the otter's prey. It was first painted on an overlay of clear acetate to make certain that the color would work with the rest of the painting. Later, the artist laid in a band of turquoise at the edge of the bank, to suggest water and to supply a variation on the crustacean's color. The body of the otter then underwent further tightening in gouache and acrylic glazing before the final details, such as the eyes and whiskers were added.

At this point, Quinn decided that a foreground element was essential to complete the work. He selected some wild rose branches with the same elliptical shape as the sandbar, and the otter's rump curve and tail. Now was a dangerous time, as the previous work could be easily jeopardized by a mistake. "I tend to advance like a carpenter, with a plan and some virtuosity with tools," says Quinn. "I hate to tear out something and redo it. I want to get it right the first time, every time." He practiced painting the foreground vegetation on overlays until he felt confident about the composition, weight, technical sequencing of paint, and color balance. As he applied the rose branch, he also added more rose hips in the form of thin bits of alizarin rose madder and cadmium orange gouache and transparent cadmium red light and burgundy lake.

SHORES AND SHALLOWS

Robert Bateman

Ken Carlson

Guy Coheleach

Don R. Eckelberry

Lars Jonsson

Roger Tory Peterson

Thomas Quinn

Robert Bateman, *Surf and Sanderlings*, 1979, acrylic, 24″ × 36″ (60.9 × 91.4 cm).

USING A SPATTER TECHNIQUE TO PAINT SAND
Lars Jonsson

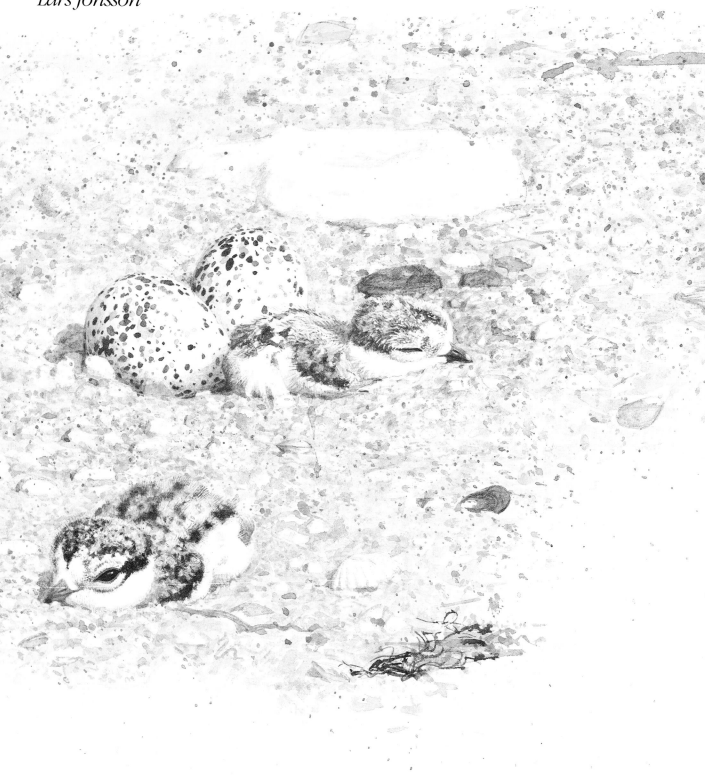

RINGED PLOVER CHICKS

1981, 12″ × 8½″ (30 × 21 cm).

Ringed Plover Chicks is an intimate portrait of newborn shorebirds at their nest, which is just a shallow scrape in the sand. Artist Lars Jonsson wanted the viewer to feel in close contact with the chicks and eggs, and so painted the work in detail. To leave the birds undisturbed, he sketched the scene through a telescope, later working from a broken egg shell, some pebbles, seashells, and a photograph of sandpiper young.

Jonsson began the painting by roughing in the major elements, and then applied a transparent background wash made up of yellow ochre, black, lilac, burnt umber, red, and ultramarine blue. Protecting the sketch of the birds and the stone with a cut-out sheet of acetate, he then flicked brushloads of pigment against the surface, spattering a variety of colors to simulate the play of hues created by millions of grains of sand. Certain areas were splashed wet-into-wet, resulting in larger spots that seem out of focus, and which help to increase the sense of perspective. The result of such random speckling gives a free and natural feeling to the painting, which otherwise could not have been achieved.

To paint the chicks, Jonsson touched the wet paper with daubs of dark umber, allowing the color to spread and merge with the surrounding areas. The wet-into-wet technique captures their downy softness. After the surface had dried, he added the necessary details, including a few "hairs" in opaque white. The eggs, barely the size of a walnut, were built up gradually, in a series of ten to fifteen transparent washes. While the surface was still wet, Jonsson blotted up some of the color to create pale highlights, then strengthened the form of the eggs with a few warm washes of lilac and black. A bluer wash would have blended with the yellow and given the eggs a greenish tone. The speckles were added in three layers: light grayish-blue, pale burnt umber, and brownish-black. Where the eggs curved, Jonsson was careful to foreshorten the speckles to emphasis the rounded shape.

This painting is part of a series of watercolors, later published as a book, depicting life on a small sandbar off the coast of Sweden. The work was done during the course of a single summer—for the artist "an intense season of sky, water, sounds, and wings." Through almost daily visits, observation, and painting, Jonsson came to feel an integral part of that small world, often viewing the birds from eye level as he lay close by in the seagrass. He watched the cycle of life unfold as young birds grew up and learned to fly, plants flowered and set seed, and migrating flocks used the sandbar as a temporary haven. By the end of August the "island" was gone, broken up by the first storms of autumn. The artist's paintings are all that remain.

ESTABLISHING AN ABSTRACT DESIGN
Lars Jonsson

AT THE DAWN—AVOCETS

1983, oil, 39" × 47" (100 × 120 cm).

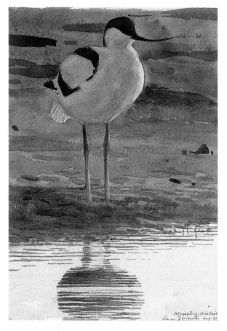

Avocets are a subject that Lars Jonsson has worked with a lot, and he made many watercolors of the birds during his study of life on a small island off the coast of Sweden. The artist recalls one occasion: "I had spent the night sleeping on the shore and was looking out at the island, waiting for the sun to rise. As it came up over the horizon, the avocets began to stir. The colors were unbelievable. The sand was dark brown, and the birds were a beautiful turquoise, backlit in gold." Jonsson worked very fast, using strong colors to capture the scene.

Two years later, the artist decided to paint a large oil of the same subject, but with a completely different approach. He created a simple, almost abstract composition based on three large color fields—yellow, brown, and yellow—with three turquoise birds in the center. He spent considerable time sketching the right proportions among the three hues with charcoal, then roughed in the brown to get a feel for the balance between the light and dark areas. Jonsson made rough drawings, cut them out, and moved the pieces of paper around on the canvas to position the birds, then laid in the water areas with a mixture composed mostly of Naples yellow and white. Once the basic design was in place, he strengthened all the colors until they reached the proper density.

The avocets were painted primarily in cerulean blue mixed with white, and backlit with Naples yellow. Their blackish areas are Prussian blue and madder lake. Where the water meets the sand and reflects the sky, the edge of the shore has some cerulean blue, and patches of seaweed are warm red where they catch the light.

The focus of the painting is on the overall design and the atmosphere that it creates, not the avocets. Establishing contact with the birds by placing highlights in their eyes would have drawn attention to them as individuals, which would have broken the spell and removed the mystery. "It is important to establish the basic message of a work and let that speak loud and clear," says Jonsson. "Details, such as additional colors, must support, not distract, from the original intent. Try to say just one thing at a time, although your message can be expressed any way that you choose."

This watercolor of an avocet at dawn, captured in bright hues of green, blue, orange, and crimson, eventually became the primary reference for the large oil.

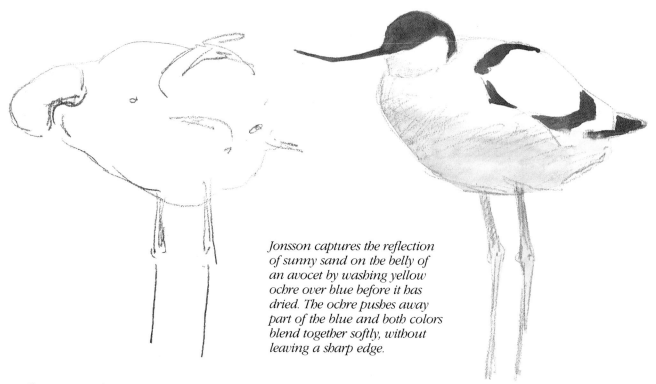

Jonsson captures the reflection of sunny sand on the belly of an avocet by washing yellow ochre over blue before it has dried. The ochre pushes away part of the blue and both colors blend together softly, without leaving a sharp edge.

CAPTURING WIND AND HAZE IN QUICK FIELD STUDIES
Lars Jonsson

YOUNG RINGED PLOVER STUDY—A WARM DAY

1981, watercolor, 7" × 4¾" (18 × 12 cm).

This field study of a young ringed plover was done very fast and loosely, using a wet-into-wet technique. With just a few brushstrokes and a very limited palette, the artist captures the atmosphere of a hot summer day on a beach in Sweden, when the light is dazzling white and contours all but disappear in the haze. Working from a faint pencil sketch, Jonsson laid a very pale burnt umber wash in the background, then flooded water across parts of the bird to avoid a sharp demarcation line between it and the background. The paler hue on the upper part of its belly contrasts with the darker background, creating a feeling of light. The artist used yellow ochre and burnt umber for the back and crown of the plover, washing on several thin layers to model some of the structures and to shape the bird. Before the surface dried, he added some dark tones to the background and on the plover's face. The artist finished with a swipe of transparent blue across its underparts, working fast to keep the color pale and wet. Had the color dried too dark, he would have worked it over again with a brushload of water, then lifted up some of the color with a tissue until the right effect had been achieved. The study was finished within ten minutes.

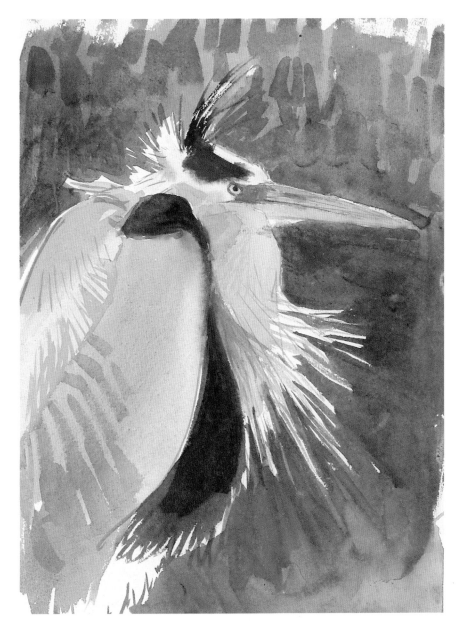

GREAT BLUE HERON IN THE WIND

1984, watercolor, 12½" × 9" (32 × 24 cm).

Completed on the spot, in just a few minutes, this painting has a spontaneous quality rarely duplicated in the studio. The portrait of the great blue heron was done one spring morning, on an island off the coast of Texas, as high gusts ruffled the bird's long neck plumes and the humidity approached 100 percent. The artist's watercolor paper flapped in the wind and the washes would not dry in the damp heat. The black on the heron's crown merged with the surrounding white areas, and it was difficult to keep it from blending with blue and pink washes elsewhere. Despite these difficulties, it remains one of Lars Jonsson's favorite American works. "I especially like this because it shows the character of the heron," he explains. "Very fast watercolor sketches can capture the quick changes in nature. This picture conveys the movement of the wind in a way that could never occur with a more deliberate watercolor or oil."

Jonsson made a rapid watercolor sketch and then began the actual painting, working all over the paper at once. The artist lets the water do the work whenever possible. A bluish wash softly overlapped a yellow-gray wash on the wing, which Jonsson found especially pleasing. To create a background for the bird, the artist mixed a high intensity green with some dirty colors on his watercolor box, spearing some of it between white spaces to create the plumes, then hinting in a purplish wash. The entire work took just fifteen minutes to complete.

CONCEALING A SUBJECT WITH LINEAR DESIGN
Thomas Quinn

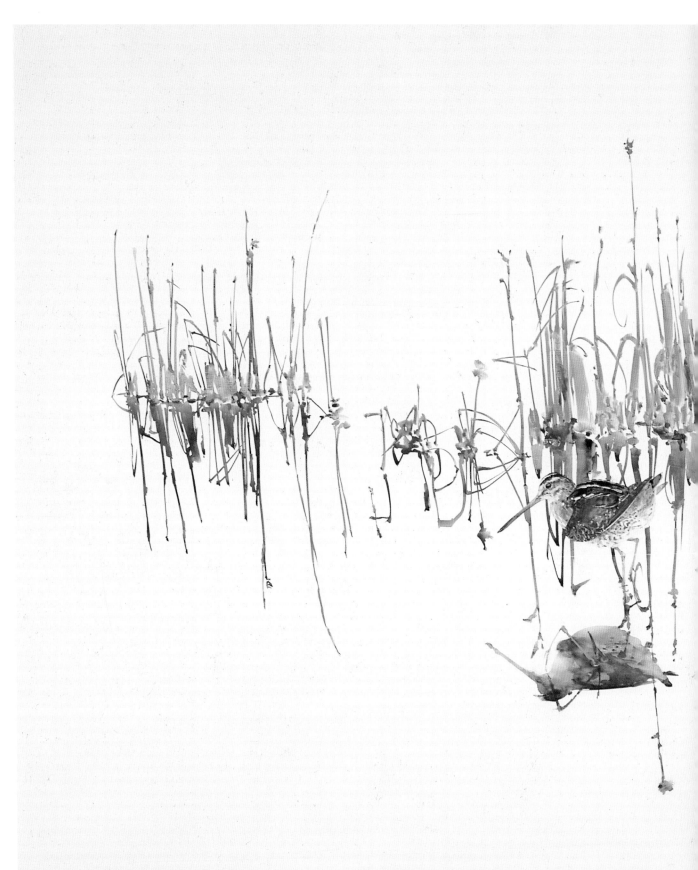

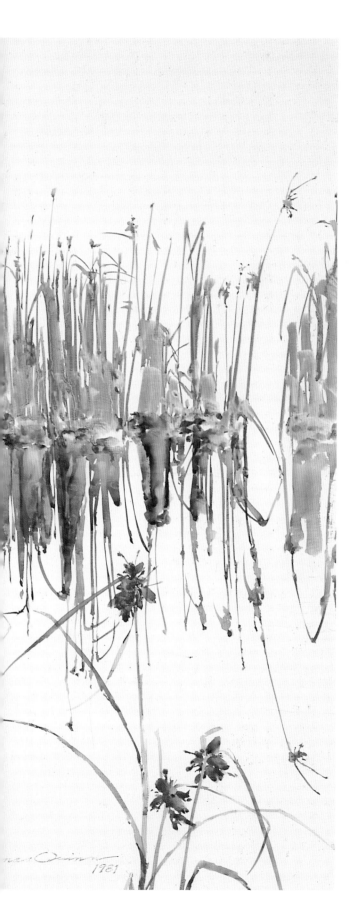

JACKSNIPE

1981, gouache, 30" × 40" (76.2 × 101.6 cm).

In spring, the jacksnipe performs a spectacular aerial display, producing an eerie whistling sound with its tail feathers. When it alights, however, the bird seems to vanish, its richly striped markings blending perfectly with the grasses that line the marshes and bogs where it lives.

California artist Thomas Quinn intended the wary, jaunty bird shown here to possess some of that lost-and-found quality. In preparation for the work, he scribbled a thumbnail diagram in black marker on the back of an envelope, which was later enlarged in an opaque projector. The nut grass, a lovely wetland plant that frequently masks the presence of jacksnipe, was executed in raw umber, yellow ochre, and ivory black gouache, with a number 12 sable brush. "I decided to allow the white gesso surface to assist in an advancing pattern of the stems and shafts of the grass," the artist explains. "I tried to set up a rhythmic cadence of aggressive brushwork and the negative slots between it, something like the arrangement of musical notes on an inscribed score." Quinn selected interesting shapes and bits of nut grass to form the emerging environment, then mixed a pool of ivory black and burnt umber and set about repeating the "score" by painting the water reflections, generally following the laws of perspective.

The artist made several tissue drawings of the snipe from six different specimens. Noting the many subtle variations in proportion and plumage color, he chose the drawing that seemed to lend itself best in shape and attitude to the linear theme. Quinn moved the final drawing around on the surface until he found the right placement. Using a gray marker, he then did another tissue overlay of the bird's reflection, rendered in silhouette only so that it was free of distracting detail. The snipe was painted, thick on its dense rich plumage, thin on the dainty underparts, in a system of bars and dots, lines, and circles, that seemed to impart the illusion of, as well as the essence of, the bird.

After he painted the bird, Quinn added a foreground stalk of nut grass to arabesque into the band of other grasses, and further detour the eye. Finally, he cropped the whole piece in order to take advantage of certain negative rectangles, and to emphasize the austerity of the design. This was done by moving and adjusting three-inch-wide strips of mat board that were held in place by push pins.

"The manner of presenting elements of the habitat is the most natural device for emphasizing or de-emphasizing the inhabitant," says Quinn. "A successful design can also lure the viewer's eye away from the subject by means of traps and false paths through devices of color, contrast, texture, and shape." His efforts at camouflaging the snipe were so successful that at one point the painting was almost reproduced upside down.

ESTABLISHING MOOD WITH BACKGROUND
Thomas Quinn

ALERT PINTAIL AND KILLDEER

1982, pencil and acrylic, 28½" × 38¼" (72 × 97 cm).

Two wary pintail drakes pause in their feeding and, one with neck extended, listen to the alarm cry of an approaching killdeer. If the situation warrants, they'll be off in an instant, vertically airborne in a commotion of water and wings. Thomas Quinn wanted to capture that moment of stillness and tension just prior to flight. He also felt challenged to work out a satisfactory composition of two overlapping birds, making a pattern of their combined markings.

The artist began by covering a gesso panel with a grainy wash of acrylics built from mars black and azo yellow orange, which he graduated from medium value to infinity with clear water. Referring to thumbnails and rough, full-sized tissue drawings, he penciled the ducks on the panel, then knocked in much of the pickleweed, and its corresponding reflections in transparent gouache. "I often find that I paint more bravely if I put the habitat in place before I invest a lot of care and accuracy in the main subjects," explains the artist. "This also helps to establish the mood, time of day, density, space, and balance in a composition."

Quinn then laid in the shapes of the pintails and added their reflections with a big sable brush. Referring to frozen pintail specimens, he used a 4B graphite pencil to delineate the fine "tweedy" marking on their plumage and form. The artist used the less dense acrylic blacks and whites before overpainting those same areas with maximum strength blacks and whites of opaque English gouache. The color of the pintail drake's head varies tonally from its darker brown crown to iridescent pale pinks and greens on the nape of the neck. Starting from a puddle of rich brown made up of Havana red and Winsor green, Quinn moved toward the pink by mixing some cadmium red light and white with the brown. The acid green was added with a touch of permanent green light. Quinn hesitated two weeks before adding the killdeer, debating whether it would detract from the ducks. In the end, he felt that it aided both the composition and the natural veracity of marsh life.

Relying on the intrinsic beauty of its markings, Quinn chose the killdeer's size, volume, and the number of brushstrokes carefully, so as not to have it conflict with the main subject.

Painting Young Birds
Thomas Quinn

Mallard Young

1981, acrylic and gouache, 13" × 19" (33 × 48 cm).

For years, Thomas Quinn has found the explorations and foraging activities of young pen-raised mallards visually compelling. Here, he decided to repeat one duckling, in various postures, as an examination of its form and to suggest their group behavior.

Quinn began by gradually washing a tilted gesso panel with water and a diluted mixture of burnt umber and mars black acrylic. After the paint had dried, the panel was turned so that the darker, denser portion was on the left. This allowed him control of emphasis by positional contrast as the figures moved from left to right.

When Quinn began the painting, he had no specific number of ducklings in mind, but wanted enough birds to develop variations on a theme and to suggest a whole hatch. The first light overall background wash was a mix of raw umber and mars black acrylic. Upon drying, this was followed by thin applications of gouache of the same tube colors that represented the bird forms, followed by transparent washes of raw sienna and yellow ochre, for various light spots and patches. The ducklings' bills and feet were painted with a mix of burnt sienna and ultramarine blue, their eyes with burnt umber and ivory black. Quinn added each duckling element until he felt that he had a satisfactory balance, in the process deliberately omitting some detailing on the left-most examples, which gave the background wash a sense of atmosphere and presence. Stalks of nut grass from the artist's weed collection were introduced to divide the space.

CANADA GOSLING

1983, acrylic, 10" × 13" (25.4 × 33 cm).

Tom Quinn's interest in painting a gosling came about while he was raising several young Canada geese from the egg stage. Lacking natural parents, they had imprinted on the artist and followed their substitute parent everywhere. Quinn wanted to paint one of his charges before it matured further, and decided to treat it as an exercise in unsentimental observation rather than a more formal work.

In keeping with the size of the subject, and to reduce any elaborate ambitions, he started on a small board, roughly a foot square, which he had primed with gesso. Quinn first covered the surface with several thin acrylic washes of raw umber, cerulean blue and a touch of mars black. He then made a light graphite drawing of the young goose on the board and proceeded to lay thin washes of transparent raw sienna and ivory black, that yielded an approximate feeling of downiness.

A gosling specimen was used to verify proportions, bill structure and markings, but the live models supplied the final details. The subtle paleness of their necks and heads caused Quinn to employ a seldom-used approach. He removed all the thin layers of paint that had been built up in those areas with an industrial grade razor blade, scraping right down to the white gesso. He then overpainted the areas again, using transparent applications of gouache in Naples yellow, with mixed variations. The darks of the bill were drawn in ultramarine blue and burnt umber, with a medium-sized sable brush, while the real blacks were reserved for the intelligent juvenile's eye.

INDICATING FORM WITH COLOR AND SHADOW/UNDERPAINTING
Ken Carlson

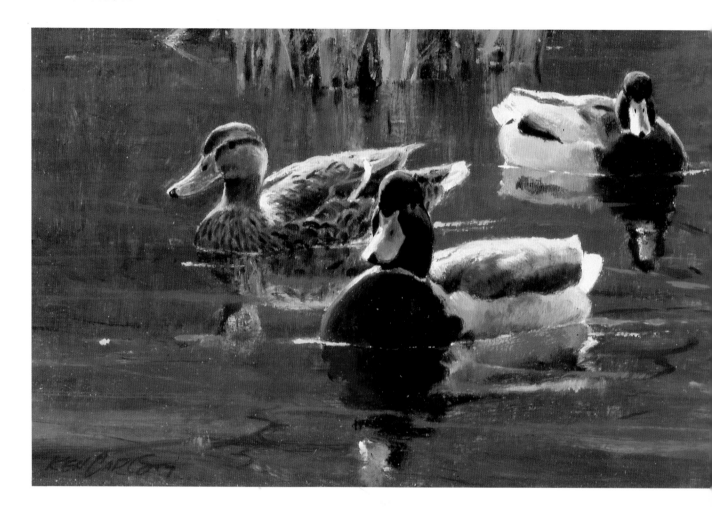

MALLARDS

1983, oil, 6" × 18" (15 × 45.7 cm).

The unusual format of this small painting came about while the artist, Ken Carlson, was doodling—drawing lines around thumbnail groupings of ducks. He had cut down the background and then felt that the composition needed more room on the right. As Carlson continued to move the lines around, he suddenly saw a different shape, with a three-to-one ratio, which he found appealing.

Carlson does all of his problem-solving at the underpainting stage, coloring everything in tones close to what he wants the finished piece to look like. Where a dark area is to be highlighted, such as the heads of the male mallards, he underpaints the area darker, then adds a clean bright accent with a dry brush, after the underpainting has thoroughly dried, to avoid a muddy effect. When the artist wants to model a paler area, as with the backs of the ducks, he first paints a middle value, then drags on a lighter shade to define the form. In both cases, Carlson lets a lot of the underpainting show through, and also goes back over the work with some of the original color to blend.

Carlson works all over the canvas at one time, establishing the mood of a painting as early as possible. Sometimes he finishes the main subject first, sometimes he waits. The artist explains, "If the painting is progressing well I don't worry about it, but if I find myself fussing with too much detail, I put the center of attention in right away. Otherwise, my eye keeps going to the more finished areas and I have a tendency to overdo them."

Here, Carlson used warm browns and golds to convey the serene mood of just before sundown. The highlighted water is painted with a mixture of cadmium yellow, yellow ochre, and white; the shadow areas are vermilion, cobalt blue, permanent green light, and raw umber. The ducks, whose bodies contain all the colors of the water, are shown in various positions to allow both backlighting and side-lighting. The reeds were painted in freehand, in cadmium yellow and burnt sienna, with a spontaneity that conveys a freshness and energy to the work.

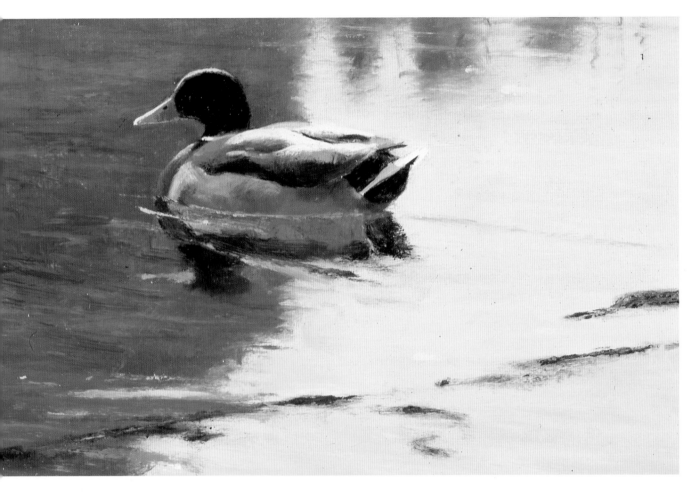

In this close-up of the foreground drake, Carlson, by showing form with color and shadow, conveys a feeling of plumage without having to paint individual feathers.

CAPTURING THE IRIDESCENCE OF FEATHERS
Guy Coheleach

MALLARDS

1979, gouache, 20″ × 26″ (50.8 × 66 cm).

Shown jumping up from an unseen pond, a trio of mallards is painted in extraordinary detail, vignetted against a simple background to give the viewer's eye a place to rest. The artist, Guy Coheleach, moved separate tissues around for placement and then transferred the highly detailed drawings onto illustration board, which he covered with tracing paper to keep clean. Removing the tissue from just the immediate area to be painted, he started with the uppermost wing of the top duck and proceeded methodically down the board, finishing with the tail of the lowest bird.

To convey the iridescent green on the heads of the drakes, an effect caused by the scattering of light rays on the surface of the feathers, Coheleach painted them in high contrast, allowing some permanent green light to pop through areas darkened by spectrum violet and ultramarine blue. The brilliant patch on the female's wing, called the speculum, is made up of ultramarine blue and spectrum violet right out of the tube. Since the other colors in the painting have been grayed, the impact of the pure pigments is further exaggerated. Coheleach distorted the angle of the female's wing to show both iridescent sheens at once. Although this twin-hued effect would not occur in nature, birds move so rapidly that the eye tends to record all the colors simultaneously.

The brown feathers on the female's extended wings were built up with glazes of raw umber and raw sienna, darker and thicker on the outermost flight feathers, and lighter and thinner on the feathers closer to her body. The artist drew each vane and break in the feathers carefully, added the washes, and then picked out the detail again. The modeling on the white feathers was even more delicate. Where feather groups changed color abruptly, Coheleach laid in a very pale initial wash on the darker set to remind him not to paint the first color beyond that point. For the open wings of the male mallards, the artist again started with a light wash to signal where to place the shadows, then applied three glazes, ranging from dark to almost white. The pale underparts of the birds were handled in the same way.

Coheleach painted the maroon breasts of the males with burnt sienna, mixed with a bit of spectrum violet and ultramarine blue. The feet and the female's bill are made up of cadmium yellow and pale marigold yellow, finished off with some cadmium orange and cadmium red pale. The bills of the male ducks are cadmium yellow light.

Coheleach conveys the iridescence of the female mallard's wing by showing both bright hues at once, although in nature only one color would flash at a time.

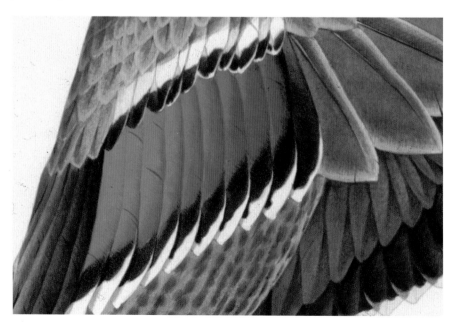

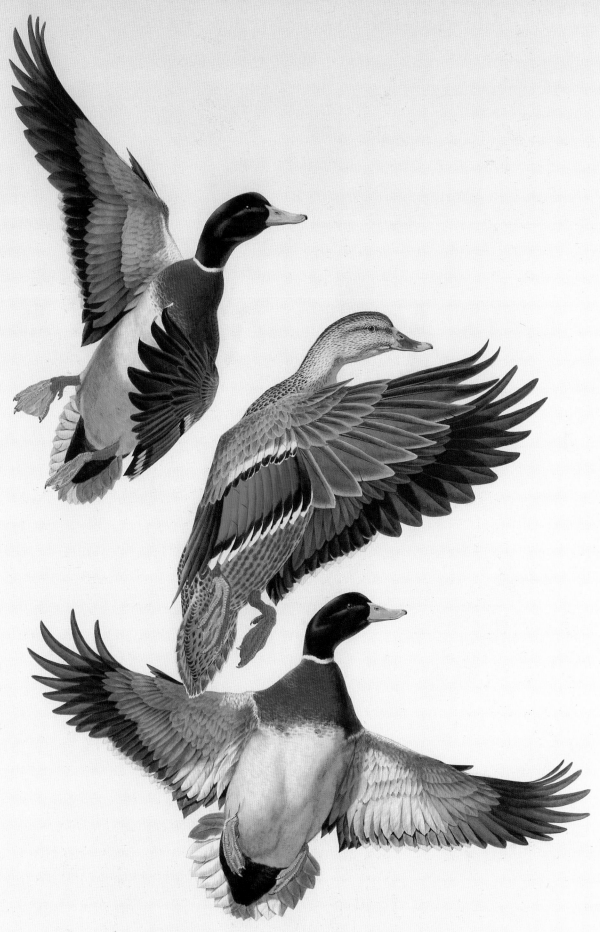

GLAZING AND SCUMBLING
Roger Tory Peterson

PUFFINS

1979, acrylic, 28" × 38" (71.1 × 96.5 cm).

Roger Tory Peterson is well known for the patternistic bird profiles in his famous field guides, and for his decorative, Audubonesque paintings. *Puffins*, with its emphasis on side-lighting, movement in space, and three-dimensional modeling, represents Peterson's more painterly style. Relying on his sure knowledge of birds and the natural environment, the artist was able to combine elements from field work on two continents to produce composition representing a scene in the Maritime Provinces, where millions of these colorful seabirds congregate each spring to breed and raise their young. The birds themselves are derived from extensive field observation, sketches, and photographs taken at colonies in Newfoundland and on the eastern coast of England; the rocks were sketched at Newport, Rhode Island; and the water is a composite that is consistent, in color and lighting, with the proper location.

Peterson arrived at the composition by cutting out sketches and moving them around until he found a pleasing arrangement. Working light to dark, he then laid down the basic black and white patterns of the birds in a series of thin, transparent glazes. Paler opaque highlights and modeling were applied over the darks by using body color with white, using a scumbling technique. The puffins' white underparts are actually a mixture of many colors, reflecting the sky, rocks, and water. Their bright bills were first painted yellow then overpainted with a thin glaze of red, which allowed the yellow to come through.

Many clear glazes, in various greens and blues, were used for the water, with some of it overlaid on the distant rocks to convey wetness. Peterson was particularly pleased with the effect of the dripping spray running off the rocks in the upper left. Since water is always on the move, the artist suggests improvising rather than trying to copy a static photograph, as sometimes accidental passages have a fluidity and a feeling about them that the artist may not be able to get from a picture.

Peterson laid out the rocks with heavy paint, using a chopped-off bristle brush for rough stipling. The surface was then scraped down with a razor blade for added texture. Peterson feels that were he to do the painting again, he probably would have used fewer puffins and added some oils, to juice the painting up more.

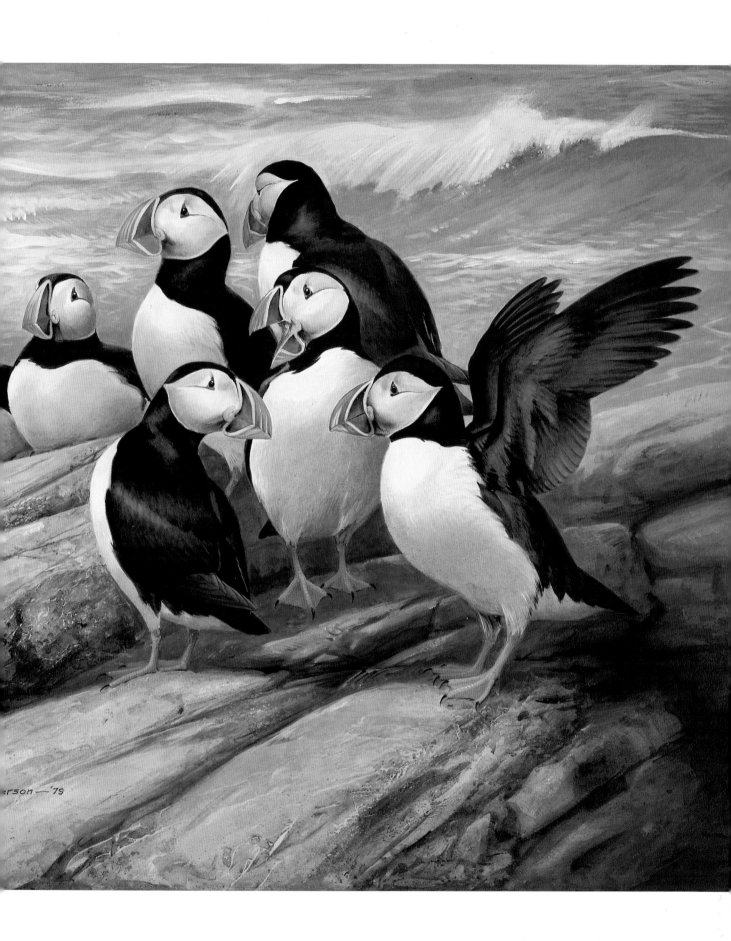

:rson —'79

CAPTURING ATMOSPHERIC EFFECTS WITH SPONTANEOUS BRUSHWORK
Don R. Eckelberry

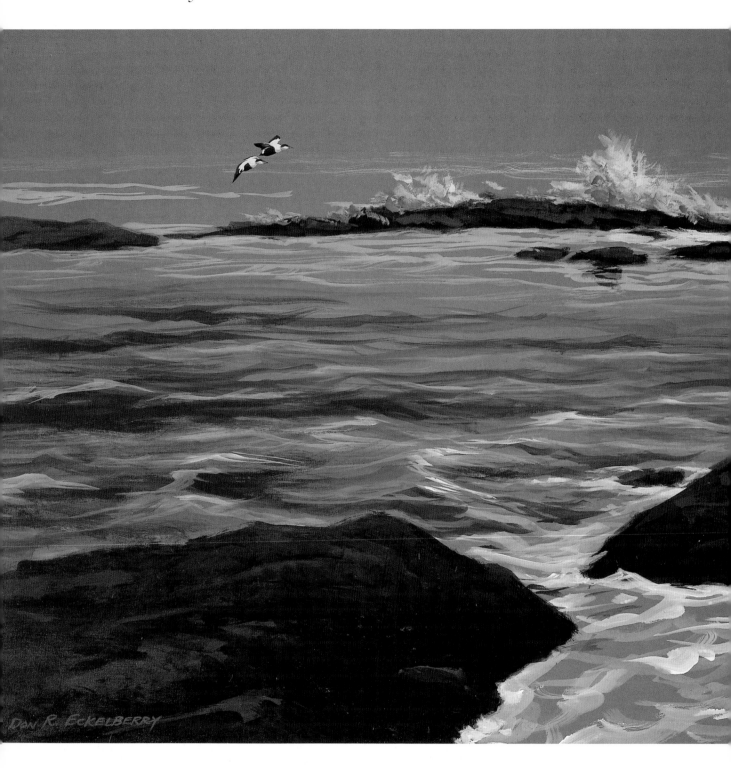

EIDERS FLYING OFFSHORE

1978, acrylic, 18" × 30" (45.7 × 76.20 cm).

One of America's most respected bird illustrators, Don Eckelberry, works in a loose, free, painterly style, where the emphasis is on atmosphere and feeling rather than sharp delineation.

Here, with an economy of brushstrokes, Eckelberry captures the feeling of a glassy sea and an overcast day along the Northeast coast. The scene is bathed in soft light; water and sky merge in the distance without an horizon. Eckelberry is a quiet painter, who prefers to show a bird or a view in a state of normalcy. This work is not dominated by huge waves crashing against the rocks; rather, the sea pushes toward the shore in gentle swells. Eckelberry thinks spatially, and is able to impart great depth to a scene that has been reduced to a few essentials.

The compositional elements for *Eiders Flying Offshore* were painted directly on the board. Eckelberry chose to work in acrylic because he feels that it combines the speed of watercolor with the greater range of oil. The picture was painted on a gray-toned ground, which gave it an underlying cohesiveness. Eckelberry worked up and down from the middle values. "When I am painting for aesthetic rather than scientific reasons," says the artist, "I usually work all over the picture, building it up evenly until *it tells me* I am finished, which is often sooner than I had planned, and sometimes later."

Eckelberry went toward the darks transparently, using the acrylic in thin washes, like watercolor. When he went up in value, for the lighter tones in the rocks and water, the artist used the paint opaquely. Once the rock masses were established, he added a few bluish and violet highlights to give them form, and then finished off the seascape with bold white brushstrokes, which give the work great energy and immediacy. The sky and some water areas were left unpainted. Eckelberry added the two ducks last. "I'm a bird man and so I stick a bird in but this is not a bird painting," he says, "it's a painting with birds in it, and they are placed there for composition balance." The entire work was completed in less than four hours. The artist feels that, for certain emotional effects, speed is essential.

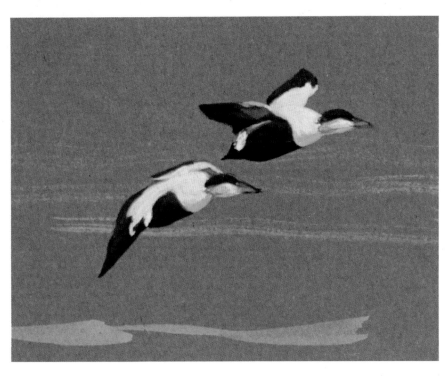

Even when not done for identification purposes, all of Eckelberry's birds are clearly identifiable. Here, the black-and-white patterns with pale-green-and-buff markings, show these to be male common eiders in breeding plumage.

ESTABLISHING RHYTHMIC TRAILS AND PATTERNS
Robert Bateman

KINGFISHER AND ASPEN

1981, acrylic, 24½" × 29½" (62.2 × 75 cm).

For artist Robert Bateman, the kingfisher symbolizes the clear blue northern waters of his Canadian homeland; and the typical tree of the region, especially in autumn, is the aspen. The artist wanted to create a picture dominated by rhythmic trails of shimmering color, rather than one with a strong central focus. By grading the tone of the leaves from dark gold to light yellow, and by modulating the water in reverse, from light to dark blue, he creates a lustrous crossover area in the center of the picture.

Bateman first roughed out the tree, which fills the entire painting, and indicated the major leaf tracts with blobs of yellow and gold. He then painted the kingfisher on a piece of bristol board, cut out the silhouette, and attached it to the panel with masking tape, moving it around until he found the best placement. By positioning the bird as though it were flying out of the scene, the artist conveys the sense of a fleeting event, like a snapshot that captures a moment in time.

The tree presented a difficult technical challenge. Aspen leaves appear to glint and tremble in the wind because of their unique flattened stems. The artist made careful studies of the leaves on an aspen tree near his studio, even returning to the site many times when the branches were bare to sketch twig attachments and to determine where each leave originated. He catches the aspen's flickering movement by accurately reproducing the many leaf angles, and establishes variations in depth by the position of the twigs and branches. Bateman's inspiration for the painting may have subconsciously derived from the work of two contemporary artists—Victor Vasarely's op art, where colors gradually change in intensity, and the dribble and spatter canvases of Jackson Pollock.

Bateman painted the kingfisher from a frozen specimen. The feather patterns on its back and wings parallel the ripples in the water. Its body is painted to reflect is biological shape, with individual feathers grading from light to dark, and from more to less detail. The wings are built up by using alternate layers of transparent grayish-blue glazes and semi-transparent white, darkened with a mixture of ultramarine blue and yellow ochre. Highlights in the shadow areas further emphasize the sense of air and space.

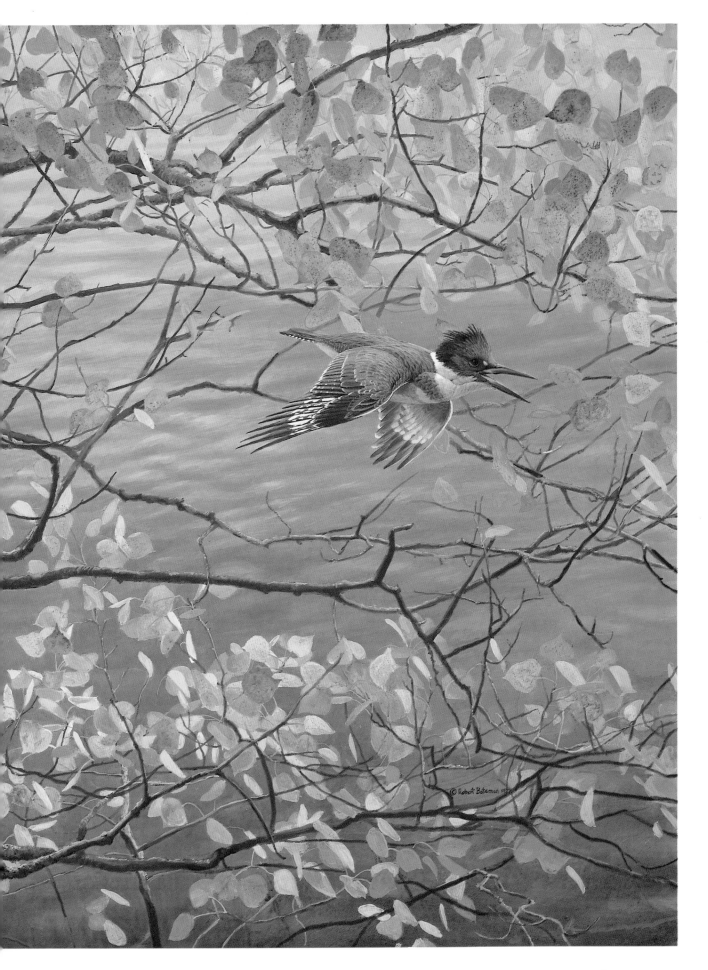

Biographies of the Artists

Robert Bateman

Allen Blagden

Ken Carlson

Raymond Ching

Guy Coheleach

Don R. Eckelberry

Bob Kuhn

Lars Jonsson

Roger Tory Peterson

Thomas Quinn

John Seerey-Lester

ROBERT BATEMAN

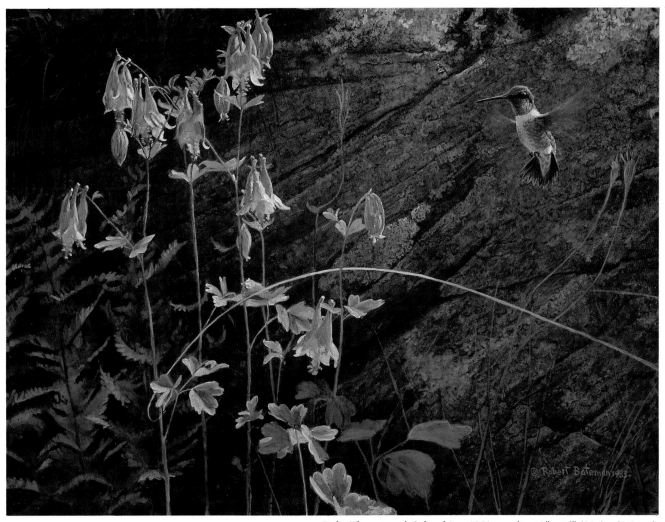

Ruby Throat and Columbine, 1983, acrylic, 12″ × 16″ (30.4 × 40.5 cm).

Photo by Norman Lightfoot

"Art is like music," says Robert Bateman. "You orchestrate the painting, giving it a theme which is echoed over and over." Bateman, born in Toronto in 1930, began "orchestrating" paintings when he was twelve. Since then, he has been most influenced by Andrew Wyeth, Rockwell Kent, Franz Kline, and Joseph Albers. He earned a B.A. in geography, a felicitous field for a man who believes in observing his subjects in their natural surroundings.

Bateman has been the subject of five films, many magazine articles, and four books, one of which, *The Art of Robert Bateman,* reached the number-two spot on Canada's best-seller list. His most recent book is entitled *The World of Robert Bateman.* In 1984 he was named an Officer of the Order of Canada, his country's highest civilian honor. His works are found in collections on four continents, including Great Britain—Canada's wedding gift to Prince Charles was Bateman's *Northern Reflections—Loon Family.* Bateman is represented by Mill Pond Press of Venice, Florida.

ALLEN BLAGDEN

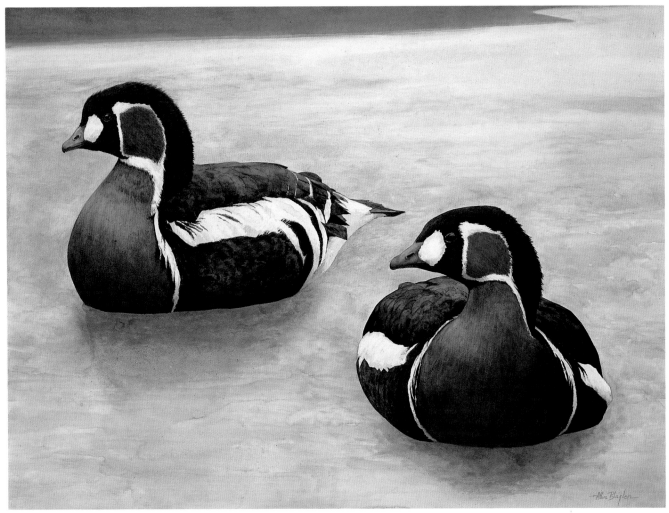

Red-breasted Siberian Geese, 1980, watercolor, 22″ × 30″ (55.8 × 76.2 cm).

Allen Blagden began his training at the age of ten with his father, artist and teacher Thomas Blagden, and graduated with a B.F.A. from the Cornell University School of Fine Arts in 1962. That same year, following a lifelong interest in ornithology, Blagden travelled to Kenya to illustrate a guide to the birds of the Serengeti National Park. Upon returning to the States the following year, he became an illustrator for the Department of Ornithology at the Smithsonian Institution in Washington D.C. In addition to his bird paintings, he is known for his portraits and New England landscapes, which reflect his lifelong association with Salisbury, Connecticut, where he grew up and continues to live. The artist also maintains a studio in New York City.

Blagden was honored with an Allied American Artist's Prize for the best "first" solo show in 1964, the Century Club's Century Association Medal in 1970, the National Academy of Design's Certificate of Merit in 1976 and Ranger Purchase Prize in 1981. Since 1964, he has exhibited regularly in group and solo shows, both in the United States and abroad, incuding the Galerie de Paris in Paris, the Trafford Gallery in London, the Wadsworth Atheneum in Hartford, Connecticut, Frank Rehn Gallery, New York, and the Kennedy Galleries, New York City, which represents him.

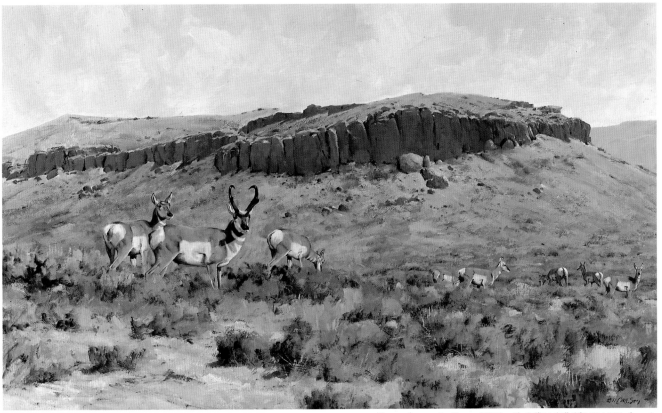

Pronghorns in Sage, 1984, oil, 24″ × 40″ (60.9 × 101.6 cm).

Ken Carlson grew up in Morton, Minnesota, population 300, where his only access to the world of art was through illustrated monthly magazines. He wanted to be an artist, however, and at age sixteen began formal training with wildlife painter Walter J. Wilwerding, at the Art Instruction School in Minneapolis. He continued his studies at the Minneapolis Art Institute, followed by a career in advertising, television, and the newspaper field, before moving to California to do freelance illustrating. In 1970, Carlson began to devote his full time to wildlife painting, and a decade later he moved to Montana, which located him in the heart of the Rocky Mountains and his wildlife subject matter.

Carlson has attained national prominence with his successful stamp designs, including the 1979-1980 National Wild Turkey Federation Stamp; 1982 Foundation for North American Wild Sheep Stamp; 1982 Texas Duck Stamp; 1984 Boone and Crockett Stamp; 1984 First Texas Turkey Stamp; and the 1985 First Texas Nongame Stamp. Carlson presently resides in the Texas hill country and is represented by Collectors Covey in Dallas, Texas.

RAYMOND CHING

Raymond Ching was born in 1939 in Wellington, on the southern tip of New Zealand's North Island, where his grandparents settled after leaving England in the 1830s for a life in the New World. (The artist's curiously un-English-sounding family name is, in fact, of Cornish origin.) A school dropout at twelve and a street urchin for several years thereafter, Ching found his fortune changing, when at age nineteen he met two artists who invited him to an evening drawing class. He discovered that he had a natural ability and has since become known worldwide for his extraordinary bird paintings.

Ching's work has been seen widely in exhibitions in Britain, the United States, and Australia, and is represented in many private and public collections. He maintains permanent studios in both New Zealand and England, to which he returns to complete the finished paintings from drawings and studies collected in his extensive travels.

In 1968, Ching painted the plates for the *Reader's Digest Book of British Birds*, and in 1978 the large folio volume *The Bird Paintings*. *Studies and Sketches of a Bird Painter* followed in 1981, and in the same year *The Art of Raymond Ching* was published. Ching is represented by Russell A. Fink of Lorton, Virginia. Prints of his work are available through Collectors Covey, Dallas, Texas.

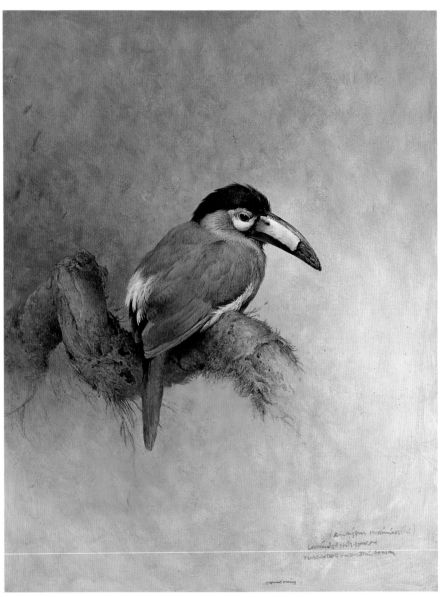

Plate-billed Mountain Toucan, 1978, oil, 19″ × 14″ (48.2 × 35.5 cm)

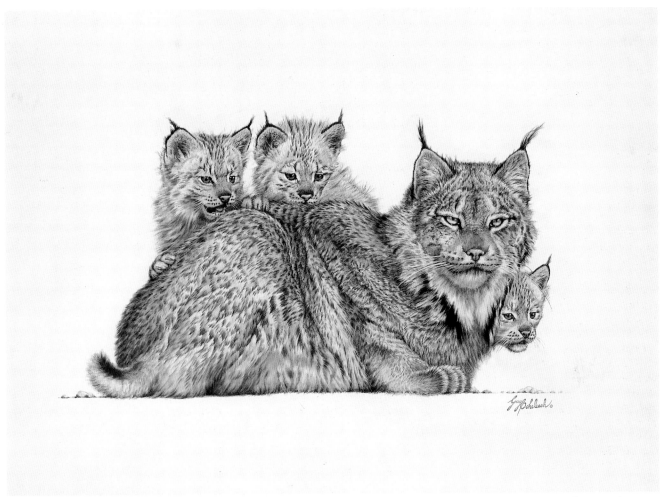

Lynx Family, 1984, oil, 19″ × 25″ (48.2 × 63.5 cm).

Guy Coheleach (pronounced Ko-le-ak) left the advertising jungle of New York City's Madison Avenue to study animals in real jungles. He has been chased by elephants, tracked lions and rhinos, and caught snakes all over the world. Not surprisingly, Coheleach is a member of the Explorer's Club and was the youngest person ever admitted to the Adventurer's Club of New York. He has been influenced by Carl Rungius, Bruno Liljefors, Louis Aggaziz Fuertes, and Don R. Eckelberry. Paintings by Coheleach, a graduate of Cooper Union Art School, are in private collections; and in the Corcoran Gallery, White House Archives, and Smithsonian Institution, all in Washington D.C., where prints of his American eagle are presented to visiting heads of state. His book, *The Big Cats* was published by Harry N. Abrams in 1982. Coheleach is represented by The Wooden Bird, Plymouth, Minnesota and Pandion Art, Stuart, Florida. Prints of his work are distributed by Wooden Bird.

Don R. Eckelberry

Shifting between easel painting and scientific illustration is easy for Don R. Eckelberry, who studied wildlife intently while roaming the woods of Ohio as a boy. By the time he was fifteen, he had formed a bird club, was writing nature columns for two newspapers, was attending summer classes in art, and was given a one-man show. Eckelberry went on to study at the Cleveland Institute of Art, and was hired by the National Audubon Society as a naturalist and artist. He left to freelance and, since then, has illustrated many magazines and fourteen books, among them the *Audubon Bird Guides*, *Our Amazing Birds* and, after turning his attention to the tropics, *Birds of the West Indies* and *Life Histories of Central American Birds*. Eckelberry was the 1979 Master Wildlife Art Medalist of the Leigh Yawkey Woodson Museum of Art, Wisconsin. Influenced by the work of Fuertes, Liljefors, and Audubon, Eckelberry has, in turn, influenced many of today's younger bird artists. He was instrumental in establishing the first nature center in the Caribbean, on the island of Trinidad, where he has done many field paintings, some of which may be seen in *A Guide to the Birds of Trinidad and Tobago*.

Cormorants Nesting, 1962, oil, 18″ × 14″ (45.7 × 35.5 cm).

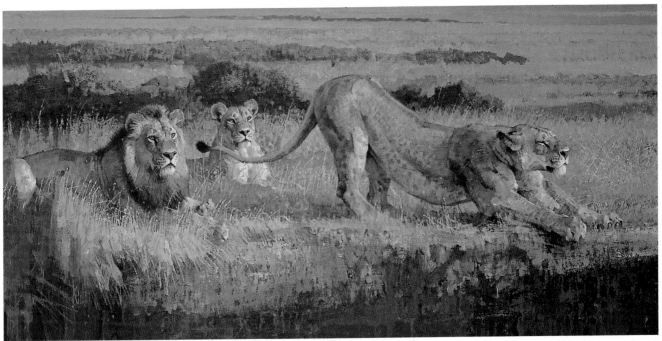

Lions Waiting for Night to Fall, 1974, acrylic, 24″ × 48″ (60.9 × 121.9 cm).

After studying at the Pratt Institute in New York, Bob Kuhn sold his illustrations to magazines—*Reader's Digest, True, Argosy, Field & Stream,* and *Outdoor Life,* among others—as well as to advertisers and calendar-makers. Meanwhile, he never stopped watching animals, a practice he began at age five on his first visit to the zoo in his hometown of Buffalo, New York. The paintings resulting from his expeditions throughout North America and Africa were exhibited and sold, and eventually Kuhn retired from commercial illustration to paint animals of his own choice. He has since become a major influence on the work of many other wildlife artists. The recipient of awards from the National Academy of Western Art Annual Show, the National Cowboy Hall of Fame, and the Society of Animal Artists, Kuhn has produced several limited edition prints, and his paintings are in many permanent and private collections around the world. His work is featured in *The Animal Art of Bob Kuhn,* issued by North Light Publishers. Kuhn is represented by Collectors Covey of Dallas, Texas; The Sportmans Edge, King Gallery of New York; and Settler's West of Tucson, Arizona.

LARS JONSSON

Born in 1952, Swedish bird painter Lars Jonsson debuted as an artist at the age of fifteen, with an exhibition at the National Museum of Natural History in Stockholm. He produced a multivolume field guide to European birds, published in eight countries, and *Bird Island*, a book of watercolors and essays. Jonsson has exhibited at museums and galleries in Sweden, England, and North America, where his works have been shown at the Leigh Yawkey Woodson Art Museum in Wisconsin, the Alaska Wildlife Art Exhibition, and the Animals in Art Show at the Royal Ontario Museum in Toronto. His painting of a gyrfalcon graced a postage stamp that was named Sweden's most beautiful in 1982. Self-taught, Jonsson has been influenced by the work of Liljefors, Fuertes, and Paul Robert. He is represented by Mill Pond Press of Venice, Florida.

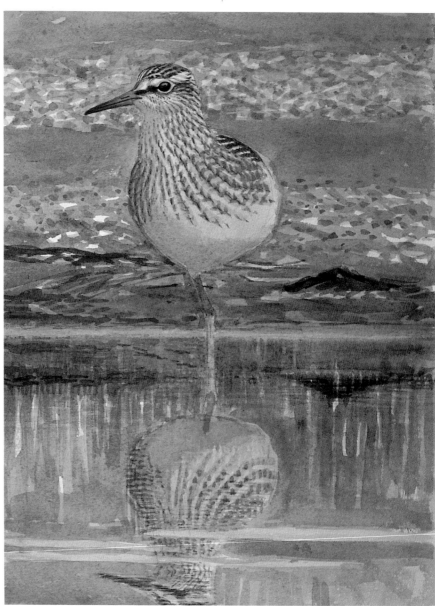

Wood Sandpiper, 1981, watercolor, 12½″ × 9½″ (32 × 24 cm).

ROGER TORY PETERSON

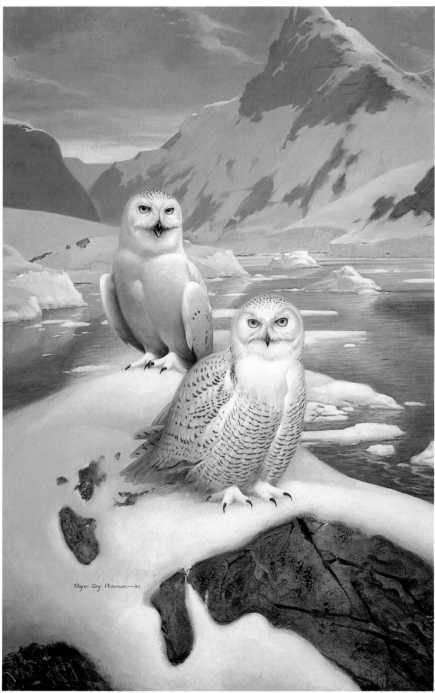

"I am a visual person who is obsessed with birds and the desire to tell other people about them," ornithologist, artist, historian, and lecturer Roger Tory Peterson has said. This he has done ever since 1934, when his first *Field Guide to the Birds*, with its system of pointing out field marks, triggered an explosion in the number of bird-watchers and set the standard by which all other field guides are measured. The guide, initially rejected by five publishers, has sold more than three million copies and, in 1984, Houghton-Mifflin issued a special commemorative edition, celebrating the fiftieth anniversary.

Peterson, who studied at the Arts Students League and the National Academy of Design under such masters as Kimon Nicolaides and John Sloan, is equally comfortable painting works in the academic manner as well as decorative Audubonesque illustrations and his field guide portraits. A former staff member and lecturer for the National Audubon Society, he continues to serve the society as a consultant. He has been awarded thirteen honorary degrees and the Presidential Medal of Freedom, America's highest civilian honor. Peterson is represented by Mill Pond Press of Venice, Florida.

Arctic Glow—Snowy Owl, 1983, oil and acrylic, 55″ × 35″ (139.7 × 88.9 cm).

Photo by Russ Kinne

THOMAS QUINN

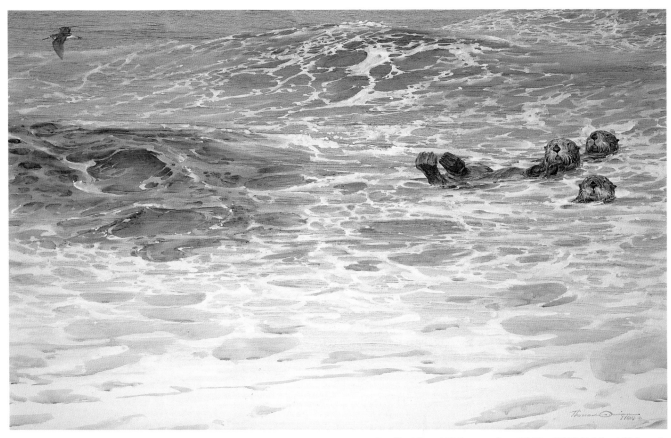

Swell Riders, 1984, gouache, 37¼″ × 56⅛″ (94.6 × 152.8 cm).

Louis Agassiz Fuertes's paintings in *Wild Animals of North America* may have sparked Thomas Quinn's interest in painting, but the artist cites Rembrandt, Velasquez, Li An-Chung, and Maruyama Okyo as lasting influences. He polished his talents at the Art Center College of Design in California, from which he graduated with distinction, and set to work doing illustrations—primarily of people—for *The Saturday Evening Post, True, Field & Stream, Argosy, Outdoor Life, Reader's Digest,* and *Sports Afield.* After a serious illness in 1966, Quinn rediscovered animals: He began to paint wildlife with more intensity and took up training Labrador retrievers. Eleven of Quinn's dogs have won major field-trial championships, and his book, *The Working Retrievers,* published by E.P. Dutton in 1983, received high praise for both writing style and content. Quinn is represented by Hayden-Hays Gallery of Colorado Springs, Colorado; Collectors Covey of Dallas, Texas; The King Gallery of New York City; and Mill Pond Press of Venice, Florida.

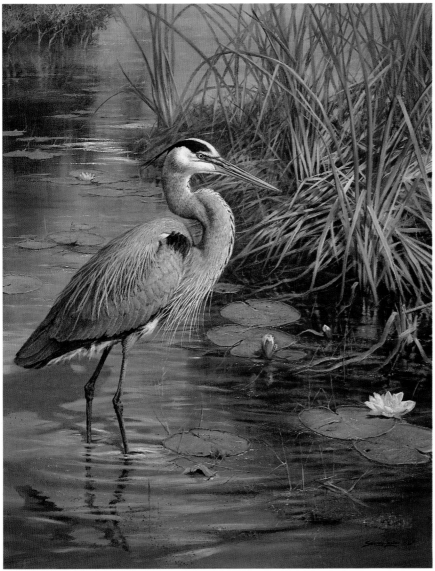

Lone Fisherman—Great Blue Heron, 1983, oil, 30″ × 24″ (76.2 × 60.9 cm).

Over the years, East African and North American wildlife have pushed aside aviation, landscapes, English nobles, and sports on John Seerey-Lester's canvases. Seerey-Lester, whose first professional commission came when he was thirteen, trained in graphic design and painting at Salford Technical College in his native England. At various times thereafter he worked at advertising agencies, served as editor of a British men's magazine, and wrote speeches for members of Parliament. His decision to paint full time followed several successful one-man shows in 1973. Seerey-Lester's art has aided many charities. His 1982 exhibition in Great Britain, held in behalf of the World Wildlife Fund, sold out on the second day, raising thousands of dollars for the preservation of endangered species. The Leigh Yawkey Woodson Art Museum, in Wisconsin, has shown his bird paintings, and galleries throughout the United States feature his originals and limited edition prints. He is represented by Nature's Scene of Mississauga, Ontario; and in the United States by Lindart, Inc. of New York and Florida. His prints are published by Mill Pond Press of Venice, Florida, where he also has lived since 1982.

INDEX

Edited by Candace Raney
Design by Jay Anning
Graphic production by Ellen Greene